HOOKED ON CELTIC RUGS

A Fresh Approach to Celtic Art in Rug Hooking

Printed in the United States of America
1 0 9 8 7 6 5 4 3 2 1

Photography by Gail Lambert
Food photography by Prime Publishing
Cataloging-in-Publication Data
Library of Congress Control Number: 2017951450

ISBN 978-1-945550-14-0

HOOKED ON CELTIC RUGS

A Fresh Approach to Celtic Art in Rug Hooking

By Gail Lambert

12 Exclusive Patterns by David Rankine

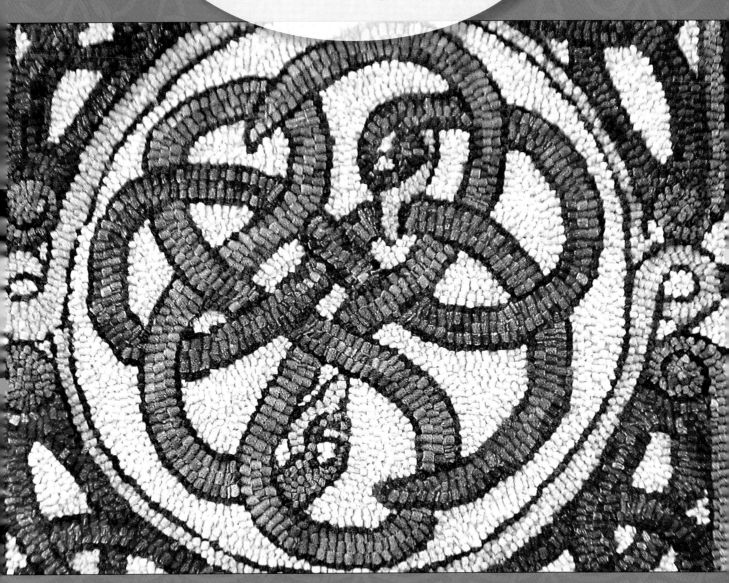

Presented by

R·U·G Hooking

Contents

Acknowledgments .vi

Introduction . 1

1. Welcome to Celtic Hooking. 4

2. Hooking Celtic Designs . 18

3. Celtic Colors .28

4. Geometrics: Finding the Rooms . 34

5. Celtic Animals . 40

6. Illuminated Letters . 46

7. Finishing Your Celtic Project . 56

8. Gallery of Celtic Designs . 66

9. Patterns. .88

10. Conclusion. 102

References . 104

Recipes

Potato and Leek Soup . 17

Scones . 27

Irish Soda Bread. 33

Slow Cooker Boneless Leg of Lamb . 39

Shepherd's Pie . 45

Microwave Custard . 55

Trifle . 65

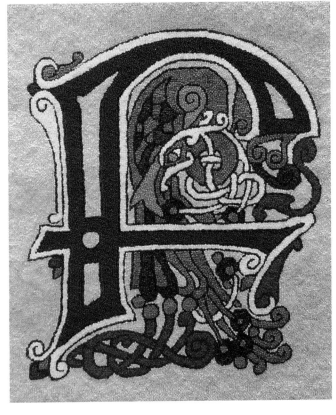
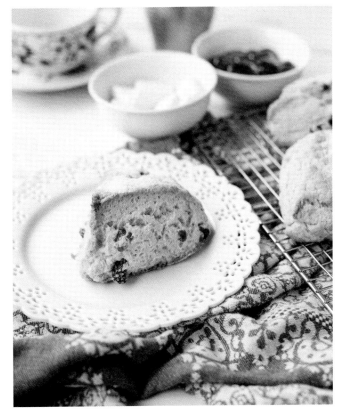

Acknowledgments

This book would have never seen the light of day if not for the talented and loving women in my family. Their encouragement in all aspects of life has given me the courage to attempt many endeavors without fear of failure—failure being a fabulous learning experience!

As well, I am deeply and happily indebted to Dave Rankine, who replied to my first email years ago, saying, "You go, girl." Without his outstanding artistic talent and his support, this book would have never been possible. I look forward to actually meeting him someday!

I also give a big thanks to Debra Smith and all the super people at Ampry Publishing who have taken my ramblings and organized them into an honest-to-goodness book.

Of course, a big thanks goes to those talented women who allowed me to include their beautiful Celtic works of art in this book. Thank you for allowing me the pleasure of teaching you a wee bit of Celtic hooking—I enjoyed every moment! Your pieces are truly beautiful!

Heartfelt thanks must be included for my friends who encouraged, supported, and sometimes nagged me during this book process—I needed all at various times.

Finally, I must thank the little people (all whom tower over me), my family. I am so grateful for my sons, each helping me in his own unique and talented way when called upon throughout this process. Lastly, I must also say thanks to my long-suffering hubby who never misses an opportunity to tell everybody his wife is a hooker. I love you all to the moon and back!

Gail Lambert

Introduction

CELTIC ART: ONE ARTIST'S INSPIRATION

The designs in this book represent a fresh and modern approach to looking at the tradition of Celtic art. Completing these patterns represents your engagement in a living culture—the visually rich realm of Celtic art. Each design you complete will represent a co-creation between you and us (Gail, the author, and David, the pattern designer).

The most common motifs of Celtic art in this book are knots, spirals, letters, and animal forms. Many of the designs also contain structural elements, like bands of solid color, to provide a framework for the piece. As you look through the designs, take note of how elastic all the motifs seem. They stretch, they spin, they writhe, they start as one thing and become another, and above all, they move.

The intricacy of knot patterns speaks of the interconnected nature of all things. Spirals speak of the flow of the dynamic forces of water and air in nature, and the birds and serpent animal forms use elements of both spiral and knot patterning. The letter forms include all three elements and defy our modern definition of letter form. They are just plain fun.

The Inspiration of Celtic Art

I began my true journey as an artist when I started looking at *The Book of Kells* and other examples of early medieval Celtic illuminated gospels. These amazing works of art from the second half of the first millennium are great source material for Celtic design and art because they contain many design traditions from not only the cultures that produced them (Irish/Scots and Anglo-Saxon) but also the cultures that the monastic communities had contact with—European, Middle Eastern, and Southeast Asian.

In those days, books were rare and precious, and the best books were the sacred texts created by the religions of those cultures. So, Irish Christian monks were coming in contact (via sacred texts) with other cultures and religions. The Irish Church's sacred texts (*The Book of Kells* and the *Lindisfarne Gospels*, for example) became a synthesis of Celtic folk art forms, Western (Roman) and Eastern (Greek and Coptic) Christian symbols, and structure and letter forms from far-off cultures. The flow of influence was certainly not one-sided, as the Irish (Celtic) Church did a great deal of missionary work, even to the extent of sending missionaries to already-Christian Italy. The most important thing to remember, though, is that it was the ideas and designs that traveled via the books.

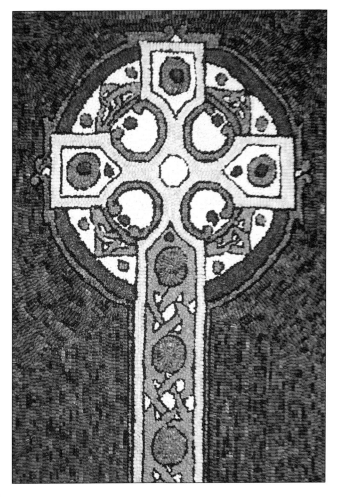

The Celts saw life as divided into three parts: birth, life, and after-death. This belief was often represented with symbols made up of spirals, circles, and triangles. Celts had no fear of dying, believing they would continue to live on after death. This belief made them fearsome opponents in battle, where they often fought naked, and with women and children taking part as warriors. "Three" was an important number in their society. For instance, women's lives were divided into three chapters: maid, woman, and crone, with crone meaning a wise elder, a person with great knowledge.

The Irish Church's closest connection was with the (Christian) Coptic Church of Egypt, and examination of sacred texts from both places reveals many similarities of design and structure. The main difference was that in one, the gospels were written in Coptic, the ancient liturgical language of Egypt, while in the other, Latin and some Greek were used—different languages, but the same message. If we push the contact further east, we can see Jewish and Muslim sacred texts looking much the same, and even Hindu sacred texts bear great similarities. Even more important than the structure of the books were the general themes involved, in particular a view of the Creator and the Creation as being a dynamic, unknowable, and limitless source of energy—a view suited to being easily conveyed by the mass detailing of knotwork, spirals, and other patterns of Celtic art. Look at the famous Chi-Rho (*Matthew 1:18*) page from *The Book of Kells*, and we see a view of the cosmos that reflects the Irish Church's view of Creation as being besotted in its relentless flow and expansion. This page breathes as does nature. The energy is roiling, trying to spin off the page. The letter forms (Greek *X*, *P*, and *I*), being the first three letters of *Christ* in Greek, provide a framework for the page, but even they become lost in the mass of movement.

Elements of Celtic Design

The Chi-Rho page is perhaps the best illustration of what I consider to be the core characteristics of Celtic design. First, there is transmutability of form as letters become spirals, spirals become knots, knots become animals, and so on.

Next, surface shimmer is created by the tremendous level of detailing on the page. This effect is also created by the use of all colors throughout the whole piece. The eye jumps from one point to the next, never lingering long. It is almost like looking at the stars on a very clear night.

Pliability of form and variation are other characteristics of Celtic art, as there is no one set way to draw anything. Knots get stretched, bent, pulled, and pushed. Spirals spin clockwise and counterclockwise, spinning out from larger spirals and spraying off their own smaller ones. Even letter forms become elastic and defy our modern sense of what makes up a letter. These are letters that live and breathe. Remember, 1200 years ago, writing was new to Ireland, and improvisation and innovation of letter form was encouraged. No printing presses for another 800 years!

Humor is an important element of Celtic design. Yes, humor.

In Celtic art, everything is playful, and there is a certain joy to the designs. These are designs which speak of interconnectedness and the fecundity of the Creation. The animals especially seem to be, well, wrestling . . . a bit violently. Serpents, fish, dogs, cats, rats, otters, butterflies, moths, people, and various types of angels, fly, wrestle, play, bite, and stare out at us from the page. In my own work, I certainly have a lot of fun creating them!

The final core characteristic of Celtic design is color. The artist-monks who created *The Book of Kells* used whatever colors they could find from plant sources or from semi-precious stones. The wealth of the Iona Monastery that created these gospels is reflected in the use of many dyes made from semi-precious stones imported from as far away as Turkey—not an easy task in those days. The "jewel tones"—bright purples, greens, reds, oranges, yellows, golds, blues—were important. Do not be fooled by photos you see of these illuminated gospels as they exist now. They are faded, dirty, and stained—1200 years will do that to you! When new, the vellum pages were bright white and the colors were intense and vibrant.

My Own Designs

These characteristics all had an effect on my own Celtic-inspired art. In over 30 years, I have never tried to be a copyist but have drawn from the source material to create Celtic art that flows out of me and is an expression of me and my interests. My design work has expanded from my paintings to rug, book, jewelry, mandala, and even garden design, all using the same design principles of Celtic art.

Not wanting to be restricted by a "traditional" set of designs, I have focused instead on the "feeling" of the art form—the riotous movement, the use of color, and the mass detailing. Not having to stick to a standard set of designs and motifs has allowed me to design without

restriction and to remain playful. After all, tradition is just an aspect of culture frozen in time. The creators of *The Book of Kells* were contemporary artists in their time, using their imaginations and borrowing, melding, and experimenting to create fresh work every time they created a new page of a new Bible.

Your Mission

How can you apply the characteristics of Celtic design to your own rug hooking ventures? Remain playful. Play with color. Experiment and be bold. I cannot tell you what colors to use, and do not feel that you are restricted to whatever historical examples survive. Make Celtic art an adventure. Bring it forward into the present as a living art form with your color. Be monochromatic with one; be fully chromatic with the next. Experiment with the interplay of opposites, like red and blue. Look at abstract paintings or at flowers for examples of color use. Use gradations of tone or change color completely halfway through a color area—those ancient Irish monks certainly did.

Above all else, have fun!

David Rankine

Arathusa Studio, Brussels, Ontario

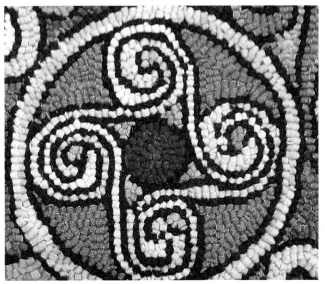

① Welcome to Celtic Hooking

Wherever you live in the world so wide,
We wish you a nook on the sunny side,
With much love and little care,
A little purse with money to spare,
Your own little hearth when day is spent,
In a little house with heart's content.

- Scottish Blessing

Welcome to the world of Celtic hooking—a complex world of mathematical precision and wild abandon, often occurring in the same design! It's a world full of delicate intricacy and grace. It's a world of bold, no-nonsense designs. For a rug hooker, it's an ever-evolving world. It's a world that takes us through a simple knot design comprised of only three ribbons, or a geometric design where each section mirrors another, or perhaps a design that leads us slowly through a complicated maze full of color. It's a world where animals bear no likeness to any seen today and a world encompassing the most marvelous designs of all—the Illuminated Letters.

How would one describe a Celtic world where such designs were created? What was an ancient Celt like? Writings from ancient manuscripts tell us the Celts were a superstitious people, cruel warriors, and headhunters who were overly fond of wine and ale. The men were boastful and quick to fight, and the women were known to join them in battle. However, at the same time, these battling warriors were creating outstanding works of art treasured by their enemies, and certainly, treasured by us today.

We know they were skilled craftsmen in many different mediums by the artifacts that have survived. They were expert artisans in metallurgy who produced both items used in warfare and exquisite jewelry; they also produced functional and decorative pottery—a testament to their level of sophistication. Indeed, ancient archeological sites still being discovered today are providing greater insights into the Celts' life and forcing some long-held beliefs of modern-day scholars to be re-examined. Our Celtic ancestors are no longer viewed, as they were by their enemies, as simple pagans to be enslaved or dismissed as unimportant.

Celtic art is now seen everywhere—in restaurants, adorning clothes, on jewelry, and in artwork of every medium. What a wealth of designs! It is possible to hook a traditional knot that may have been part of a design on a warrior's shield or an illuminated letter from a gospel book from thousands of years ago. Recognizing that art is constantly evolving, there is also an unending supply of modern Celtic designs to tap into for more hooking ideas.

The designs in this book marry the two views, ancient and modern, in unique patterns never before seen or hooked. We hope you will find them both interesting and challenging.

While a simple loop is the only stitch required for any of the Celtic designs in this book, there are a few easy techniques to consider when hooking these designs to ensure a professional finish to

your chosen project. I'm happy to share some of the tips I use when hooking my designs in the hopes that they will make your project easier to complete.

David has designed twelve beautiful new patterns just for this book. They proceed in difficulty from beginner level to more complex designs best suited to the advanced hooker. Take time in choosing the first one you will hook. Look at each of the patterns carefully. Determine what size would be best. Will it be a centerpiece for a table? Will it grace a sideboard at Christmas? Is there a sofa in need of an accent pillow? Is there a space calling out for a mat to greet visitors?

Determine the type of use the piece will have. Will hot dishes be placed on it? Will it be in a high-traffic area? Are there pets in the house that may adopt the mat as their own? Cats in particular enjoy using mats to sharpen their claws, and some pets take great delight in unhooking mats with claws or teeth. (I'm speaking from experience. I own a small dog that developed an attachment to a fine hooked pillow and adopted it as a favorite chew toy. He could pull out dozens of loops much faster than I could re-hook them. Lesson learned: The pillow now rests on a spare bed, out of his reach.)

Consider the materials you will use. Will it be hooked only in new wool? If you use recycled material, will there be enough to hook the whole design? Maybe a smaller pattern will be better suited for that repurposed skirt fabric. Will you hook it with yarn? If so, be sure to buy adequate amounts of the same dye lot. The finished work will be marred if the letter has two unintentionally different shades of blue because you ran out of your original color.

One word of caution: Don't start with one of the larger, more complicated patterns if you have not hooked a Celtic pattern before. It is best to ease into these patterns. Start with a small design

that will not take months to finish. It's hard to remain enthusiastic about a project that drags on forever. It is also faster to pull out and re-hook spaces in a smaller design should you change your mind about something, like color. Hooking a small knot pattern that is quickly finished is a great boost for both confidence and for working out the directional hooking found in Celtic ribbons that twist over and under themselves.

Once you choose the pattern and size, any professional copy shop can enlarge the design for a very reasonable fee. Show them the permission on page 89 and there should be no problem. Please do keep in mind, though, that David makes his living by designing, so the patterns are for your personal use, not for resale.

Transferring the Design

Once you have your design at the desired size, the question becomes how to transfer what you have onto a suitable backing. I use red dot transfer material, placed right over the design and held on gently with pins, to trace out my designs. Red dot material can be purchased at any fabric store, and most hooking shops carry it as well. This material is sheer, and the pattern can easily be seen through it. The equally spaced red dots make a grid so that you can match the design lines to the dots, thus ensuring your pattern will be transferred onto the backing in line with the backing fabric.

It is important to trace the pattern squarely on the backing. If your pattern does not line up in straight lines on the backing, it will throw the entire design out of alignment, and you will have a finished mat that will not look pleasing or press flat.

For tracing the design, a good set of fine-tipped markers is worth the money! I have used cheap markers and found that they wear out sooner, fade, rub off on my wool, or bleed through the finished design. I use fabric markers in different

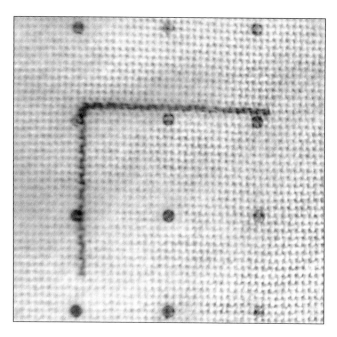

It's important to keep the red dots straight with the backing.

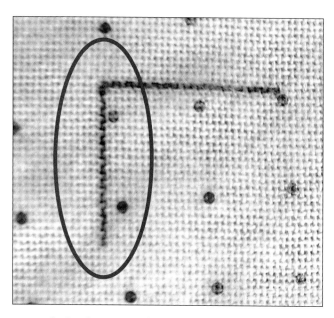

A design out of alignment cannot be hooked successfully.

colors when color planning, but the tips are not sharp enough for tracing. Look for a sale, as good-quality markers can be quite expensive. Be careful where you trace—cheaper markers may bleed through the red dot and the backing and onto the surface underneath. My dining room table bears witness to this!

Colored chalk is handy when working with the paper copies of your design. Chalk is great for plotting out ribbon designs with all their twists and turns. It can be erased easily from the paper, leaving no permanent marks on your pattern. A paper pattern used this way should last for a good long time, barring any accidents with coffee.

If you transfer your design using red-dot material, your markers may get snagged on slight hairs that come off as you trace. If this happens, just don't press as hard. This material is quite delicate, and the ink from the marker will travel through it, even with slight pressure. Remember to relax your shoulders and breathe. This is just a simple tracing job, like learning to trace your first letters in grade school.

A Word about Backing Material

Talk to hookers about backing material, and you will get interesting conversations. Some will only use burlap because that's what was always used and it's traditional. Some will only use linen, and others use monk's cloth or cotton warp. Each hooker has reasons why their choice is the best—it is always a personal choice. I can't use burlap because my hands break out in a rash and I sneeze constantly. Linen is lovely to work with but a bit pricey. My material of choice is rug warp: it is soft on the hands, it has no objectionable smell, and more importantly, the threads are perfectly spaced with no nasty slub lines (those wider variations in the threads that can occur with burlap and some linens).

Each of those backings will work, so don't be put off from working with what is at hand. By all means, use burlap if that's all that is available. Burlap is often sold in kits because it is not as costly as the other backings, and it's been used for centuries. There are different types of burlap: primitive burlap, which has wide open holes, and fine premium burlap, which will only hook up

with a smaller cut of wool. Burlap is a good choice if you are trying to keep the cost down.

Linen is softer than burlap, and wool pulls through the holes easily. Like burlap, it has fine hairs that will sometimes show on the face of a mat, but these do not affect the wear. Hairless linen is available, but it is more expensive than regular linen.

Rug warp works well for Celtic designs in that it will accept narrow strips of wool, like #3, #4, or #5 cuts. A #6 cut will go through with a bit of tugging, but the fabric will distort.

Hooking Tip

I never use a #6 cut in Celtic patterns. Most Celtic patterns have small, compact designs within a larger design that won't translate into hooking with wider cuts. A good example of this would be the feathers within the body of a bird, or crossovers that are intertwined in a knot. The fine detail needed for feathers can't be managed with a larger cut in these small spaces and can only be achieved with a #3 cut. Another example would be an eye of a bird, which may only require a tail, a loop, and a tail to define the pupil. This tiny spot has no room for any cut larger than a #3.

Don't hesitate to ask your local shop for advice when choosing backings or supplies; they are there to help. Talk to other hookers and ask why they are using that particular type of backing for their pattern. There are many books and magazines available to help you decide what is needed to begin hooking a pattern. Don't forget your local library and the Internet. There are numerous free demos and clubs to join that have a wealth of information for the novice hooker.

You can also experiment. Once you have finished a project in burlap, for example, try hooking your second design in a different backing, or if first using linen, try burlap or rug warp. A path of discovery will help you learn which you prefer to work with.

PLANNING FOR YOUR PATTERN

There are a number of points to consider when contemplating your pattern. Of course, color is one of the most important, and we will look at that later. Let's look at a few other considerations.

Outlining

First, everything is outlined in a #3 cut! Yes, I mean everything, and we ignore the rule of hooking inside the line. All outlining is done *right on the line*, except where two lines pass each other. (You never want to have double lines of outlining side-by-side.)

If a hooked line is already there, start and stop when the two lines meet. I also suggest that you don't outline everything at once, as there is a risk of confusing yourself. To keep the design looking

Where two outlines meet, only one line should be hooked. Double outlines look thick, and the clean flow lines of the design are lost. This is an example of what NOT to do.

crisp and clean, you want only one line of the darker brown or black, which is used to imitate the lines drawn by monks so long ago. They used a quill, which was a crow or goose feather that was squared off on the tip. Where they used ink to outline, you use wool.

Most Celtic designs, as was the case with those created by the ancient Celts, are busy—the exception being knots, which are fairly easy to understand. These are complicated mats, and success depends on the attention you give to outlining. It does take time to make a wonderful Celtic design. However, remember that it took upwards of 30 years to complete one illustrated page in *The Book of Kells*—you will be finished much sooner than that!

Strip Size Considerations

Most hooking is done with strips of 100 percent wool cut into different widths (more on that in Chapter 2). Because there are many different shapes in most of these patterns, a hooker might wonder what size strip to use. Spend time looking at your design. I can't stress enough that knowing your pattern will save much heartache later. It should be obvious that an eye or a claw can't be hooked in a #5 cut. However, the background will hook quickly in a #5 cut. Remember that every outline is hooked first with a #3 cut, and that has to be taken into account when considering the neighboring cut. You have to plan ahead to know if your #5 cut will be beside a #3 cut; if that's the case, the #3 cut will need to be pulled up higher so it won't get lost beside the taller #5 cut.

If the line seems to disappear after hooking is done on each side, pull your outlining color a little higher until you can clearly see it.

Yes, this may mean you'll have to pull out some of those hooked loops, but you will soon learn to avoid those situations. Many of the more complicated designs will have three sizes of cuts in the finished mat. One easy way of determining what size cut to use is to lay your strips between the hooked outline and see how they fit.

Placing different cuts side-by-side on the design can help determine the proper strip size best suited for that section.

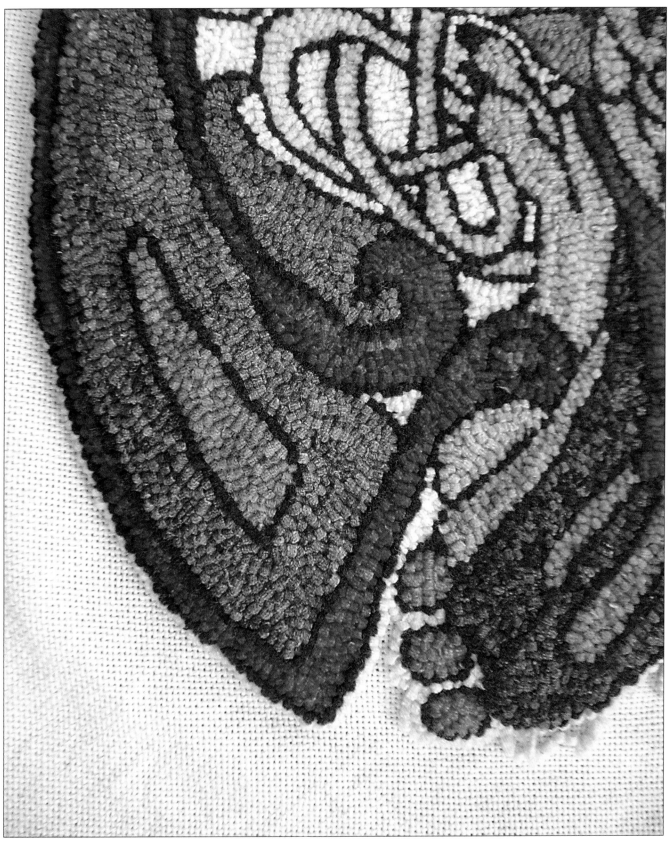

Notice how the black outline color defines each section clearly when pulled high enough. Hooked claws are good examples of this, as is the narrow-to-wide flow of ribbons in some letter designs. I enjoy the connection this gives to the carpet pages from the ancient gospel books. They used gold leaf; I use yellow wool.

A #3 cut when hooked higher will give a crisp outline.

• •

Will it take two strips of a #3 cut and still have room on each side? Try placing #4-cut strips and see if those will fit better. Use whatever works for that space. If you hook the entire pattern, including the background, in a #3 cut, the finished piece will have a rich, velvety look.

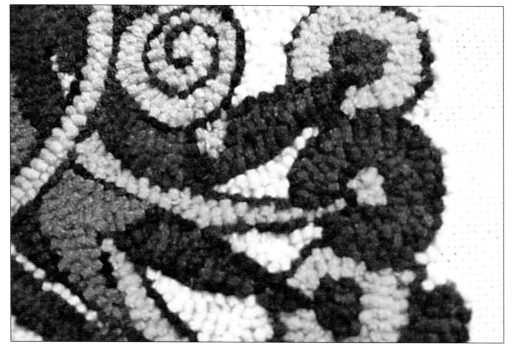

A #3 cut can get lost if not pulled up to match a higher cut.

• •

HOOKING POINTERS

Circles

Many of these designs have circles placed in them somewhere. Sometimes they are one of the most important parts of the creation; sometimes they are little accents. Either way, the circle symbol was very important to the Celts, and we need to be careful when hooking them.

Hook around the circle with the surrounding color and it will act as an anchor line, stopping the circle from expanding. Here, the circle was hooked in yellow with the holding line hooked in turquoise.

One of the problems with hooking circles is they grow. What should have been a neat little dime-sized circle becomes a distorted quarter. You definitely don't want this to happen as you hook an eye! To avoid distortion, before filling in the circle, hook around the outside perimeter with whatever color is to be used in that space.

This achieves two purposes. It stops the dreaded blob, and it will show whether there are too many loops for the circle outline.

Here is how I hook a circle.

1. Hook the outline. If the loops are crowded, pull some out.

2. Next, find the center of the circle and pull up a tail at 12:00, then a loop at 4:00, and another at 8:00, ending with a tail back in the 12:00 spot. You now have three stitches in the center looking a bit like a triangle.

3. Fill in around the clock hands, being careful not to pack in too many loops.

4. Hook a row inside against the circle outline and fill in another row if needed. The wool will expand to fill in the open spaces, so it is not necessary to fill every hole. Indeed, if you do fill every hole, you will have a circle that will be popping up because there is not enough room for the wool to lie flat.

Points

There are only a few Celtic designs that don't have a point somewhere. When moving on to the illuminated letters, you will discover there are often dozens of points. There are two ways to approach these. One is to start and end with a tail in each point.

This method is the easiest but doesn't always give a solid point. If you are a beginner, this method is a good way to start learning about points. Be careful that additional colors do not start or stop at the same point. Too many tails ending or beginning in the same location will give a fuzzy, vague look to the point instead of the sharp, distinct point you are looking for.

The second method is to start about halfway up the point. Pull your loops with the tip of the hook facing toward the center of the point.

It helps to visualize a line, or even draw a line, going up the center of the point. When you reach about two spaces before the top, skip over those holes and pull the next loop up at the tip of the point. Skip two spaces going down the opposite side, then pull up the next loop. You may have to pull the loop at the tip up a bit higher because it has to fill in the empty spaces on either side.

Hooking Tip

When you are outlining, there are times when you need to fill in a small spot. This will happen particularly when hooking Celtic geometrics. There is an old cross-stitch trick that works well in this situation called "parking your wool." When your hooked strip meets another line crossing over it, take the leftover strip from the underneath side and move it off to the edge of your design, out of the way, and pull one loop to the surface. This anchors the strip to keep it firmly out of the way until you are ready to hook more outline.

This is a view of the back with a strip parked out of the way until it is needed.

Hooking with Yarn

You may like to work with yarn instead of with wool strips. If this is the case, don't worry—Celtic designs work well hooked in yarn too! You may need to fill in more holes when working with yarn than with wool strips, where it is possible to skip one space each time. Either material will give you a beautiful mat. If you are hooking with yarn, be sure to buy enough yarn in your chosen dye lot to complete the project. It is frustrating to end up with an unintentional different color variation because the dye lot has changed.

The tip of a point can be hooked by starting and stopping at the tip.

Keep the tip of the hook facing in toward the center of the point.

Begin hooking partway up the line. Always pull the loop higher at the tip.

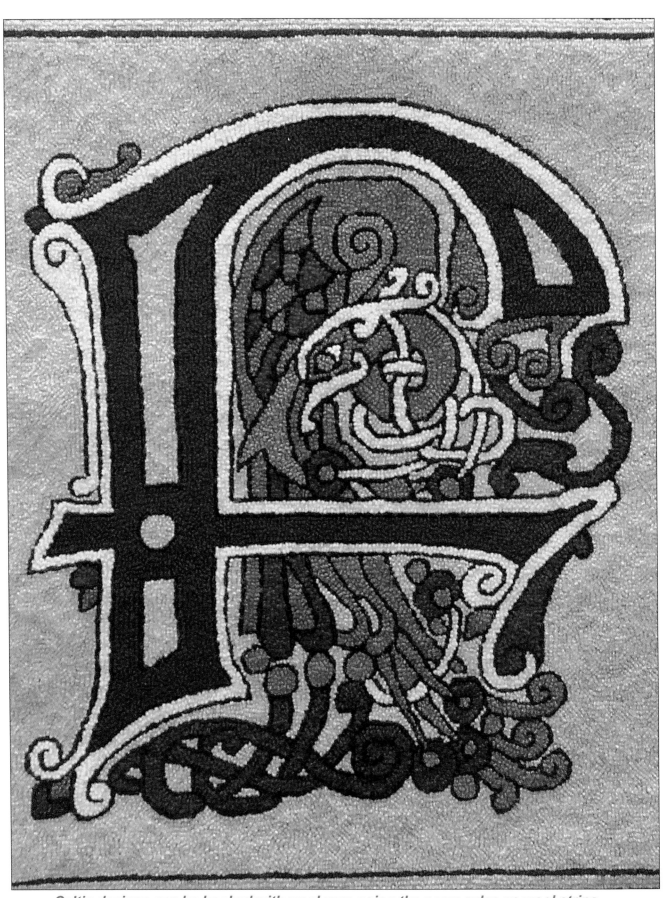

Celtic designs can be hooked with wool yarn using the same rules as wool strips—hook on the line and fill in small sections as you hook.

Frames

We've talked about the pattern and we've talked about the backing. Now let's consider hooking frames. There are as many styles of frames as there are opinions about them. Some stand on the floor, some fold down flat, and some tilt; there are circle frames and square frames. Some hookers use a hoop not attached to any frame, and there are large frames where the pattern is laced in securely and rolled as it is completed. How to choose?

If you are a beginner, I suggest passing on the most expensive models; keep your cost low until such time as you know you are "hooked" on hooking. Check around; if you are lucky, you may find a shop or group that loans out frames for a small fee.

One of the advantages of a hoop is the cost and availability—hoops are inexpensive and easy to find in craft shops. However, a disadvantage is that they need to be held as you are learning how to hook. You might feel like you need three hands! A word of caution: If you decide to use a hoop, be sure to get one made of wood that has a large metal screw attachment that is turned to tighten or loosen the top hoop. This will allow more room for the material as the wool covers the backing. Another disadvantage of hoops is resistance. What do I mean by that? It is very important to have the backing tight—which can be achieved with the hoop, but you must then find a position to hold the hoop while pulling the wool to the front. This is not an easy task for the beginner who needs both hands to manipulate the wool and hook. Having a supported frame that sits on your lap or stands on the floor frees both hands and removes the difficulty of holding the hoop.

Whether using a frame or a hoop, stretch or pull the material tightly so your hook will go through the backing, grasp the wool, and bring it to the surface. If the backing is saggy or loose, the hook will have no resistance and the wool strip will be pulled off your hook as it is tugged through the material. Loose tension will also cause the hook to get caught in the backing material. A good way to check for proper tension is to drop a dime on the backing. If the dime bounces, the backing is tight enough; if it does not bounce, the backing is not tight enough. Be aggressive and pull the backing tighter! Be certain the backing is placed on a square frame straight and not crooked. If the backing is not straight, you will have wavy lines and distortion that will affect the finished design. Be aware of the straight of grain in your backing and make it work for you.

Hooking Tip

HOOKING WITH A HOOP

Sometimes backing material pulls or distorts easily, and you find it difficult to maintain the tension when you first start hooking with a hoop. If you can't tighten the top screw any further, remove the top ring and wrap a thin strip of cotton fabric around the bottom ring. This should fill it out, increasing the tension until you hook enough loops to make the hoop tighter. When you have hooked enough to keep the tension tight, remove the cotton strip. Too much tension can break the wooden rings. Metal embroidery hoops won't work for hooking because they have tension springs that can't accommodate the fullness of a hooked mat.

A frame with metal strips, called gripper strips, on all four sides allows for easy placement of the backing and is the most popular kind of frame. Smaller lap frames are popular because they travel well and are more portable than floor frames.

My grandmother laced the two long sides of her backing to pieces of wood. The two smaller sides were laced onto two shorter wooden pieces that were then clamped on to the longer boards. This made for a rigid frame that was placed over chair backs when she wanted to hook. The best method is the one that works for you!

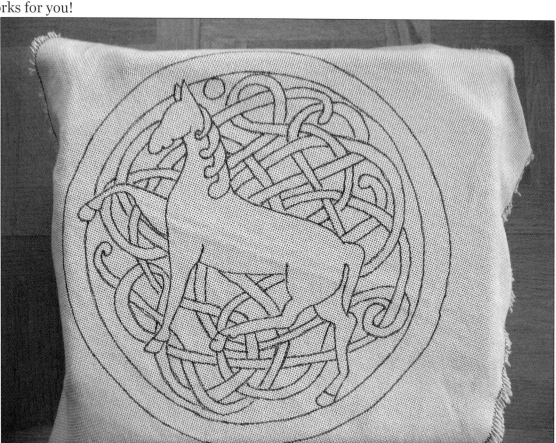

Be certain that the backing is straight on the frame with the threads in the linen parallel to the sides of the frame. This pattern is not placed squarely on the frame. If left like this, the design will be difficult to hook and may be wavy when finished.

• •

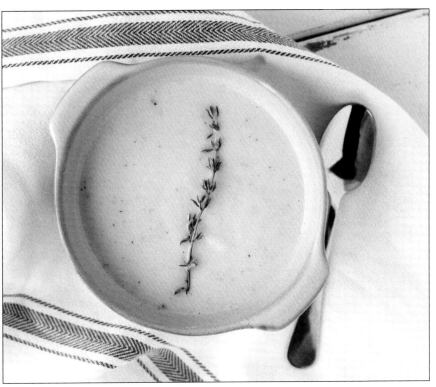

Potato and Leek Soup

2 Tbsp. butter

1/4 cup olive oil

2 sprigs fresh or 3/4 tsp. dried thyme

6 leeks, sliced thin, white part only

4 potatoes, peeled and diced

4 1/4 cups chicken or vegetable stock

Salt and Pepper

Optional: 1 to 1 ½ cups cream or milk for a thicker soup. Thyme for garnish, optional in a large pot.

Heat the butter, oil, and thyme the over medium heat. Add the leeks and sauté gently for 5 minutes. Add the potatoes and sauté for another 2 minutes. Add the stock and simmer for 30 minutes. Cool slightly, and then blend until smooth. Reheat gently, adding the cream, if desired. Sprinkle with salt and pepper. Ladle into bowls and serve, garnished with thyme, if desired.

Now, after reading all the different terms, rules, and explanations, if your mind is spinning, treat yourself to a nice hot bowl of soup. It's easy to make, and you can enjoy this recipe with the family—they'll think you were working hard all day!

② Hooking Celtic Designs

May the roof above never fall in,
May we below never fall out.

- Scottish Blessing

THE CELTIC KNOT

If this is the first piece of Celtic art that you are hooking, the simple Celtic knot is a good place to start. Take time to look at the design before you start, and you will see there are some lines that cross over and others that go under. This typifies Celtic designing, whether it's jewelry, pottery, carvings, or hooked rugs. Think of them as highways—every time you have an overpass, you must have an underpass. When tracing the lines, you must stop each time you meet an intersection or you will have an accident! And when you hook the lines, you must have a plan.

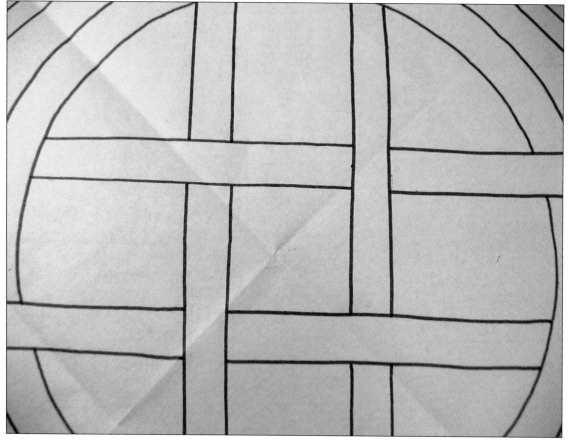

Spend time getting to know the design before you begin to trace it. Pay special attention to the overs and unders.

Tracing the Design

The first question to ask is, "How do I get the design from the paper to the backing?" The most common way is to use the red dot transfer material that I introduced you to in the first chapter. Red dot is a see-through fabric with evenly spaced red dots that enables one to see the material underneath. Here is how to trace your pattern:

1. Using a fine-tipped felt marker, follow the lines of the pattern, tracing the entire design.

2. Press lightly so the red dot doesn't bunch or stretch. Pressing too hard can also cause the marker to bleed through the red dot and mar the paper pattern lines. I never use my red dot pattern more than three times; after that

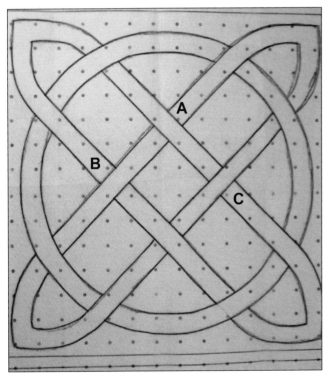

Trace over the design using a fine-tipped marker and red dot material. First place the red dot material over the paper design, making sure the straight lines of the pattern align with the red dots. You can pin the red dot material and the paper together to stop them from slipping apart.

some lines begin to blur, and it becomes easy to confuse where one line ends and another starts, particularly when doing feathers or fine geometric lines.

3. Place the red dot over the backing material, making sure the pattern is straight on the backing. If you examine the material closely, it's possible to see that each thread has a valley between it and the next thread. It's important to have the valley lines match with the straight lines on the red dot pattern. You may need to tug the backing one way or another to straighten it out. Do this before you pin, or the red dot material will tear. Pin the pieces in place when you are sure the lines are even.

4. Start at the center right corner marked with the A, and begin tracing toward the top left, doing both sides of the lines, one after another. Stop when you reach an overpass.

5. Then move on to the B and C sections and do the same each time.

6. Start tracing in the center of each design and trace outward. This will keep the backing material from bunching up in the center. If it bunches, the design lines will not be even, and the finished product will look wavy.

This is what the design should look like when partly traced.

7. I suggest that you trace toward yourself, if possible, to avoid your hand blocking the pattern lines. Get into the habit of tracing both lines at the same time. This will keep you oriented when doing the more complicated patterns in the book. A knot is fairly easy to follow, but a letter is not!

8. Before tracing the outside border, remove the red dot material and retrace any lines that are not clear. I have a trick to get a good, even outside border that is equal on all sides: I count the threads from the outer tips, then draw the line right on the backing. Do the same on the other side, counting the same number of threads. You may find the tips are not exactly the same number of threads from tip to outside border line. Don't worry if the count is one or two threads off; it won't be noticed when finished.

This design will hook up quite nicely in a #5 cut, and although I suggest hooking the outline in a #3 cut for all other designs, if this is the first Celtic pattern you've hooked, I suggest using a #5 cut. Hooking this design using a #5 cut will be good practice in gaining loop control. I don't advise a beginner to try hooking with smaller cuts of wool because it is difficult to gain proper control of the wool. It is easier to see when crossovers or twists occur using larger wool strips.

All of the design outlines I hook when doing a Celtic letter or geometric are in a #3-cut dark brown or black wool to imitate the ink used in ancient manuscripts. Don't worry if you don't have black or brown for the outline color; use what you have and have fun!

To ensure the outlines remain in position, I hook the background color against the outline before filling in any part of the pattern.

Once the outlines are hooked around the motifs, fill in by hooking first against the outside of the outline, then on the inside of the outline. This ensures the outlines remain in position. Any filling in that is needed should be worked between these two hooked lines, always going in the direction of the outlining.

Count out from the tips to achieve a straight border.

Hook the background color to help hold a crisp outline.

Hook in the direction of the design—always work with the flow.

Hooking Tip

Don't cross the wool underneath any overpass! The finished mat will look lumpy, and the wool in those crossed lines will wear out faster in the general wear-and-tear of the mat.

Starting to Hook

The act of hooking is complex. Hooking involves pulling one loop of wool to the surface after another, with each loop the same height. When watching an experienced hooker pulling up loops with little to no effort, it looks like simplicity itself. The beginner is always shocked when they struggle with the first few loops, which either fight to appear on the top or refuse to stay put. It is absolutely necessary to have the backing

material, whether you are using burlap, rug warp, or linen, held tightly. Lack of tension in the backing material is one of the biggest and most overlooked problems for new hookers.

Don't get discouraged. Few tasks in life come easily the first try. We missed our mouths when we began to eat, we fell repeatedly when attempting to walk, and we had to practice many hours behind the wheel to obtain our driver's license. There is no reason that hooking should be any different. Don't be frustrated: practice, practice, practice!

What makes hooking so hard? As you hook, one hand is hidden! Not only is it hidden, it must perform a very important secretive task: looping a tiny strip of wool around a small metal object while achieving the right amount of tension for a successful loop. It's little wonder that the beginner has one loop slip out while struggling to pull up the next. Frustration ensues.

This is a good tip for any beginner: Take a good look at the hook, and you'll see that the shaft of the hook generally widens as it approaches the wooden section. When pulling loops, always push the hook all the way through the material. Many beginners tend to use only the "hook" part, which will not open up the fabric wide enough to allow the wool to pass through to the top without either pulling it off or shredding it.

Always push the hook through to the widest part of the shank to open the backing material.

A Word about Hooks

Hooks come in a variety of sizes, shapes, colors, and materials. It's best to try one out before purchasing it. Don't rush out and buy a hook made from an exotic wood from Africa. It won't make you learn any faster!

Hooks generally are available in three sizes: fine, medium, and coarse. The size initial is often stamped on the end of the handle. Beginners are advised to start with a coarse or medium, as finer hooks are more prone to shredding the wool when you are first learning hook control. The size of the cut wool strips will determine what size hook to use: #3-cut wool strips require a fine hook, #4-cut wool strips will use a medium, and #5 and up will use a coarse hook.

If you are using a coarse hook and a #3-cut wool strip, the hook will make a hole too large for the small strip of wool, so the wool will not stay in place. If there are no markings on the hook, try a number of different cuts to see what works best for that hook. Most hooking shops have a hooking frame set up so you can try a number of different hooks.

A ball type hook is the most economical and the most common. Ball hooks sit in the palm of your hand and are often made of wood, with the end in the shape of a ball. Pencil hooks are long and thin and are held differently, with the body of the hook resting on the web between the thumb and first finger. These require a slightly different hand technique when hooking.

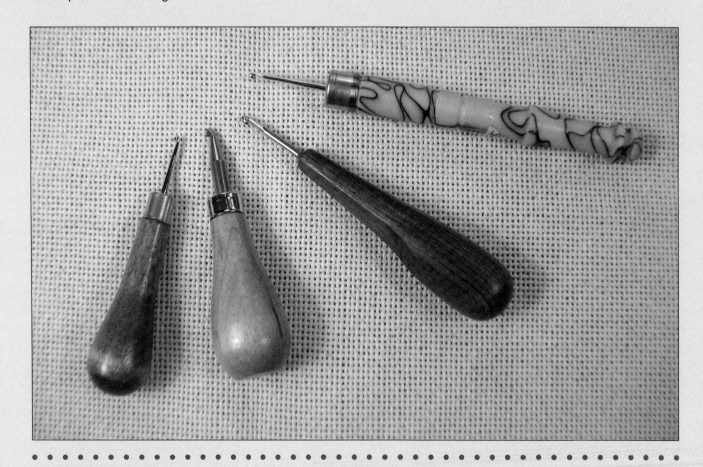

A ball hook

A pencil hook

My much-loved and much-used hook; note the finish has been worn off one side! After many years of hooking, I have settled on a bent hook with a thicker handle. This works wonderfully for me, and I can hook for hours with little hand or wrist fatigue, something I was plagued with when using a thinner hook. Warning to new hookers: You will find over time that hooks are like shoes and purses—you can never have too many! (I won't tell you how many I own!)

All About the Wool

Once the pattern is drawn on the backing, the backing is under proper tension on a frame, and a hook has been chosen, your next step is deciding what material is needed to hook the pattern.

The most common material used in hooking is wool fabric. This can be either purchased as new yardage or found as clothing in second-hand shops. All new fabric is treated with a product called sizing to help keep it in shape and discourage moths. This needs to be washed out to make the fabric fuller. A small drop of detergent and hot water will achieve the effect you need. The material can then be hung on the line or dried in the dryer, but be careful it doesn't "felt" up or get too dense.

If using recycled material, check to see if it is pure wool or a combination of wool and a synthetic. A blended wool can be used, but it may damage your cutter wheels. Here are two simple tests to discover what kind of fabric you have. (Caution: Always hold any material to be tested well away from your face.)

• Cut a small piece of fabric, approximately 2″ x 3″ and, holding it over the sink or outdoors, light it with a match. If it's wool, it will smell like burnt hair and put itself out. If it is a blend, it will flare or spark. Be careful of sparks that may fly!

• The second test is not as dangerous. Cut a 1″ square of fabric and put it in a jar with about 2″ of bleach. Leave it overnight. If it's pure wool, it will dissolve; if it's a blend, there will be fibers left.

This is an easy tip for determining how much wool you will need: take the fabric and fold it into four equal sections, then place it over the area to be hooked. The fabric folded into fourths will cover about that amount of backing. One piece of advice: Always buy more than you think you will need; never buy less because it is frustrating to run out and not be able to find that wool again!

If using wool fabric bought as yardage, it must be cut into suitable strips for your project. If you start with a beginner kit, this is generally already done. There are machines designed to cut multiple strips at once for this task. Some cutters will clamp on the side of a table, and others may have suction cups on the bottom to keep them from moving. No one machine is substantially better than another, they all do the same job. They are the most expensive item in the hooker's closet, but if you are patient, second-hand machines can be found at a fraction of the cost. Local hooking

Cutter wheels - Width of strips

#2 - 2/32 of an inch (think thin yarn)

#3 - 3/32 of an inch

#4 - 4/32 of an inch (1/8″)

#5 - 5/32 of an inch

#6 - 6/32 of an inch (3/16″)

#7 - 7/32 of an inch

#8 - 8/32 of an inch (1/4″)

groups are generally aware of machines for sale. When buying a used cutter, check for rust on the wheels and the machine body, which can be an indication of internal damage. If properly stored and cleaned, these machines are virtually indestructible and far outlast their owners.

The fabric strips cut by these machines vary in width depending on the wheel size used. Each wheel has a number marked on the side indicating the strip size it will cut: #3, #4, and so on. The higher the number, the wider the strip, increasing each time by 1/32″.

If yardage is purchased, tear it into smaller sections before attempting to run it through the cutter. Fold the yardage in half widthwise and make a small cut on the fold approximately 1″ long. Grasping the wool in two hands, on either side of the 1″ cut, pull apart. The best method to stop shredding is to pull one hand forward and the other back for about a foot. Don't pull the fabric apart like a V; that causes too much distortion in the fibers and is wasteful.

Never tear fabric away from itself like a V as this causes wastage.

Stop shredding your wool by using proper hand placement—one forward, one back.

Fold each section of the material again, make another snip on the fold, and tear apart till you have 1/8-yard pieces. This can now be torn into 3″-wide pieces that will be suitable for running through the cutter.

Smaller strips ready for the cutter.

Running a large section of material through your cutter is not wise. The weight of the fabric will pull in away from the blades, and it will cut on a slant rather than straight. This will in turn cause the wool to shred on the hook as it is being pulled through the backing. Take the time to make smaller manageable pieces to cut into strips.

Pulling up Loops

You are now ready to begin. Remember, I advise beginners to use a coarse hook and a #5 cut. Push the hook through the backing, pushing the length of the shaft. Holding the wool with the hidden hand, use your thumb and index finger to place about an inch of the strip over the hook. Keep slight tension on the wool underneath while pulling the wool end to the surface. This is called a tail. Place the hook in the hole next to the tail and again push the hook through, using the full shaft to open the backing. Place the wool over the hook and, keeping tension on the wool underneath, pull up a loop to the surface. You now have a tail and one loop! Repeat this procedure, pulling up one loop at a time. Try to keep them the same height.

Yes, the one before will often pull out as the following one is being pulled up. That is common for all beginners; pull the loops higher and try again. I repeat: practice, practice, practice. When you finally get to the end of the strip, pull the end to the surface and start the next strip in the same hole.

Look at the row you just hooked and notice that each loop has two sections—one piece of the strip going up and another going down. Each hole hooked should always have two pieces of wool in it, which is why a tail hole has the beginning and ending of a strip in it. One standard mistake made by new hookers is to leave long tails on the surface. These long tails will eat up the material. You don't need million dollar tails! The tail needs to be only a fraction above the surface; the excess gets cut off later.

Which direction to hook in is a personal choice and you will discover your preference after you have hooked for a bit. Some hook left to right, others right to left, some top to bottom, and others, bottom to top. If you are right-handed, it is generally easier to hook right to left, with the left hand guiding the strip under the backing and keeping it from the hook. The opposite would work for left-handed hookers. Top to bottom works well because you can clearly see the pattern, but the wool is more apt to get tangled in the hook underneath. Hooking from the bottom up uses more wool. It is harder to see, and visually it looks like there needs to be wool placed in every hole, which is usually not the case.

Hooking Tip

To check if the wool is pulled high enough, place the strip being used on its side by the row you are hooking. The top of each loop should be even with the width of the strip.

Over time, you will develop a height that is comfortable for you, and the terms "high hooker" or "low hooker" will make sense when you hear them used. Which will you be?

Design Note: *Signatures are very important! When planning a project, think where you would like to see your signature. Should it be at the bottom, where most artwork is signed? Maybe there's no room at the bottom, so it will need to be placed elsewhere. Do you want only initials or your whole name? Some hookers hide their name inside the pattern, and others hook it boldly. Some hook block print and others hook script. Often, there will be no signature visible on the front—information is recorded on a label or the twill tape. Providing as much information as possible is a terrific idea. Labels on the back might list the hooker, the name of the designer and/or shop, the occasion (if it's special, such as a wedding), the date hooked, and sometimes the cuts used and whether any pieces are stored under the twill tape for repairs.*

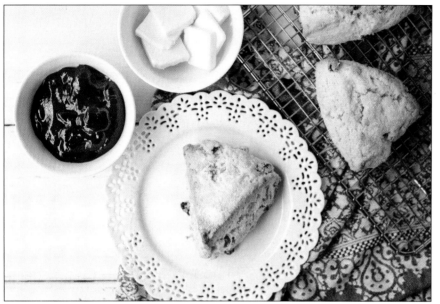

Scones

2 cups flour, plus extra for dusting a work surface

1/3 cup sugar, plus extra for dusting

2 1/2 tsp. baking powder

1/4 tsp. baking soda

1/2 tsp. salt

1/3 cup shortening

1 egg

2/3 cup sour cream or soured milk. Coconut milk will also work.

1/3 cup raisins, optional

1/3 Jam and butter for serving

Preheat the oven to 400°F. Mix together the flour, sugar, baking powder, baking soda, and salt. Using a fork, the add shortening and mix until crumbly. Beat an eggin a separate bowl, then add 1/2 cup sour cream or milk and raisins. Add to the dry mixture, all at once. Mix until just blended. If the mixture is too dry, add more of the cream or milk, as needed. Knead for 10–15 seconds on a floured surface. Form into a large circle, about ½″ high. Score into wedges with a sharp knife and sprinkle a small amount of sugar over top. Bake for 20 minutes. Serve with jam and butter.

After all your hard work, it's reward time. Bake these super scones, put on the tea kettle, invite a friend over, and relax. You can impress her with a yummy treat, and with all you've learned so far about the wonderful world of Celtic hooking.

③ Celtic Colors

May green be the grass you walk on,
May blue be the skies above you,
May pure be the joys that surround you,
May true be the hearts that love you.

- Irish Blessing

The early Celtic artists were restricted in their color palettes by the availability of color choices at the time. We are more fortunate! When you look at *The Book of Kells* or the *Book of Lindisfarne*, both ancient gospel manuscripts, it is easy to see just how limited the color choices were for these works of art. Glancing through my palette of colored wools as I approach a new Celtic project, I try to keep my colors in harmony with those used by my distant ancestors—dark brown for the outlining, yellow, green, blue, red, turquoise, and the regal purple of the Druids. For me, each of these colors is easily obtained by mixing powder in water. How different from centuries gone by! Although I have hooked many pieces using dark brown for the outline, as I was taught, I have switched to black after conversations with Dave. He explained how the inks at that time were black, not brown. The brown seen now is the result of a thousand years of fading.

Acquiring most colors was an arduous task for dyers in the ancient past. Yellows came from the soils in certain parts of Ireland; emerald green, from copper; violet blue, from the woad plant, known as dyers' weed; verdigris, a greenish blue, from the patina formed on copper; ultramarine, a rare, brilliant blue, came from Arab countries, replacing, when possible, a deeper blue achieved from the indigo plant; red was derived from red lead; other pigments such as mauve, maroons, and purples were imported from the Mediterranean.

Today, it is not uncommon to recognize that colors have unique psychological qualities, such as a soft blue or green, often found in hospital or dentists' waiting rooms for their calming capabilities. So, too, did the Celts link colors with certain powers or magical properties. Yellow represented the sun and was one of the most exalted colors, signifying love and dignity. Purple was considered a regal color and was linked with wisdom and power. Blue was connected with truth and green with hope. In fact, early Christians banned the use of green because it was used in many pagan rituals. But it later became popular as an emblem of victory, with the winner or person of power being awarded a crown of aromatic laurel leaves. Red signified fire, perfection, and purification.

Most art found in the gospel's books was drawn on vellum, which is an animal skin that had been treated to produce a fine, soft material similar to suede. The vellum would have been a beautiful soft white. While I have tried hooking a variety of white shades for my backgrounds, I found them to be lifeless and somewhat stark. I use a dye formula that is created from a blending of cream and beige. This produces a warm background color and works well with the vibrant colors I use.

The colors that work best for Celtic hooking are the simple crayon-box colors. If it worked in 698 CE and has stood the test of time, it will work now! The palette is really about six to eight colors. While this is a small number of colors to work with, the designs are so varied and unusual that many unique mats can be achieved even with such a limited palette. But don't get hung up on using only certain colors. While it's nice to have connections, we are not limited or restricted to following and replicating what David refers to as "dead art." There's always room for exploring and expanding, both for ourselves and our art. Why not try a monochromatic or a limited palette? I have seen lovely Celtic mats hooked in shades of one color using different values, and I've seen beautiful pieces using only three colors. I doubt that an ancient Celt will visit you in the night shaking a fist because of your color choice.

COLOR PLANNING FOR CELTIC ART

Color planning for a Celtic mat is not much different from the color planning for a regular mat. You want colors that will work together in a harmonious fashion. We all have our own preferred color palette, and that differs from person to person. I have one friend whose palette consists of dark colors, using shades of browns and reds. I always enjoy watching her pieces come to life, but trying to use her palette will not work for me. An exercise using her palette means trouble and unhooking for me!

Jelly rolling can provide a quick visual guide. It will tell you if colors will work harmoniously together or clash. Even though the red, green, and yellow are intense, these bright colors work well with their neighbors. You can see that the two shades of brown work nicely together in a roll, the purple jumps out, and the lighter brown disappears.

When I first begin planning, I look at the largest section of the particular design I'm working with (excluding the background, which will be the vellum color). When I have identified that space, be it a bird's body or the shape of a letter, I will use the color I want for that space, and then choose the other colors working outward from it. I can't say I use the strongest color for that section because I've hooked mats using almost every one of the colors as the central theme. In most cases, I find yellow works as a good choice for small spaces. Yellow is intense and can overwhelm its neighbors if large amounts are used as the focal point. The same applies to orange. Use these two as your poison colors.

If using other colors not in the Celtic range, still pick out the main space and color. Then try this trick: jelly roll the colors you plan to use beside and around the main color. Do this by placing strips of each color on top of one another and rolling them up loosely.

If one color doesn't work, is too weak or too strong, it will stand out from the others. Go back to your stash and try again. One of the easiest rules to follow when choosing mat colors is this: one bright, one dark, and one poison. Let the other colors complement those, and you will generally be successful. Always take time to play with your colors!

It's fun to play with color! Notice how the knot with the lighter colors—yellow and orange—looks bigger than the one with the darker colors.

I have had mats that told me immediately what colors they would be—no argument! On the other hand, I have struggled with a design, even though the colors worked well together when I was choosing the palette. I had to pull out, rethink, and reposition many times to achieve the proper "voice" of the design. Don't be discouraged by these trying lessons. Every time a loop has to be pulled out or a color changed, something is being learned. I find we generally don't remember the successes nearly as well as the failures.

Design Note: *Color wheels are invaluable and well worth the money. A visit to the hobby section of any craft store or bookstore will provide a wealth of information about using color. You will find color theory books available for all levels of experience; some even have colors wheels in them. Visit a paint store for handfuls of color chips that can provide hours of enjoyment as you play with different color combinations. It is not necessary to invest in buying large numbers of books or magazines—you can find inspiration all around. Check out your local library. Take time to look at mats done by others and study how their colors work with, or in some cases, fight with each other. Keep notes on what pleases you and what you don't like. Get to know your palette—it may surprise you! My hooking palette is totally different from the palette I choose for my wardrobe.*

Spot Dying for an Authentic Look

Traditionally, jewel colors are used for Celtic hooking, and they produce beautiful mats. They are rich, solid colors. But after looking at *The Book of Kells*, I noticed that few of the colors were solid. Considering that all work was done using a squared-off goose or crow feather dipped in ink (the best quills were made with swan feather!), it would be very difficult indeed to achieve a solid consistency. Taking that into account, I

experimented using spot dyes and discovered the effect was much closer to the original manuscripts. Spot dyes bring movement and life to the designs that was missing when I used only solid colors. Time spent experimenting is never lost, even if you don't get the result you were seeking. As you experiment, you will learn so much about what will work, but more importantly, what won't.

There are places that benefit from using solid colors; those are the small accent spaces. These might be small circles or perhaps the smaller feathers of a bird. Using spot dyes in these smaller spaces sometimes leads to vagueness, and the accents get lost because they are not crisp. These small accent spots are super places to use bright yellows or oranges. Hook one small circle using a spot dye and one using a bright solid color, and it will soon become clear which one stands out.

Always try to have any color used in a mat repeated in at least three places. This gives a unified flow and continuity that balances the piece. These three spots need not be large spaces of color. Having all small circles the same color but spaced around the design will work beautifully.

A solid color works best for small accent circles.

A spot dye, when hooked, is vague. The orange is hooked using a smaller cut but still provides a stronger accent than the larger spot-dyed section.

Borders

Do take care when considering what color you will use for a border. A dark color is always best to define the design if you are looking for a finished, framed look. Lighter colors used on the outside edge of a mat can give a floating, unanchored feel. I use a beauty line, which is one line of color approximately 1″ in from the mat edge. I hook the color line and the outside strips using a #5-cut strip to provide a more solid, stable finish.

The most important part of color planning any mat is to have fun. Explore and discover what will happen when a shocking pink is placed beside an intense orange. Analyze what happens when dark blue and dark brown are placed side-by-side. I believe each color has a voice; our task is to make them sing together like a well-rehearsed choir.

A single line of the main letter color, when hooked around the outside edge, provides a lovely beauty line.

Irish Soda Bread

4 cups flour, plus extra for dusting the work surface

1/4 cup sugar

1 Tbsp. baking powder

1 1/2 tsp. salt

1 tsp. baking soda

6 Tbsp. cold butter, cut into small pieces

1 1/2 cups buttermilk or coconut milk

Preheat the oven to at 350°F. Combine the flour, sugar, baking powder, salt, and baking soda. Cut in the butter until coarse crumbs form. Stir in the buttermilk. The dough will be sticky. Knead the dough on a floured surface about 10 times. Form into a ball; place on baking sheet lined with parchment paper. Cut a large X in the center of the dough with a sharp knife. Bake for approximately 1 hour, until it is light golden brown around the edges. Place on wire rack to cool. Slice and serve.

Why not try baking a warm and hearty bread as a reward for what has been achieved so far! This bread is yummy served with jam and is perfect for either afternoon teatime or breakfast.

④ Geometrics: Finding the Rooms

Wishing you a house of sunshine,
Hearts full of cheer,
Love that grows deeper each day of the year.

- Welsh Blessing

One of the best descriptions of Celtic art I have found comes from Professor Paul Jacobsthal quoted in *The Ancient Celts,* by Barry Cunliffe: "Their art is full of contrasts. It is attractive and repellent; it is far from primitiveness and simplicity, it is refined in thought and technique; elaborate and clever; full of paradoxes, restless, puzzlingly ambiguous; rational and irrational; dark and uncanny."

These words apply particularly to Celtic geometric designs. There are patterns that repeat within themselves, shapes that are the same size, and mirror images. There are patterns with mathematically exact repeats and patterns that leave you searching for balance. We can make sense of these more complicated designs by breaking them down into their basic shapes.

When faced with a Celtic design for the first time, try taking away the frills. Look for the strongest point—is it a center knot or is it the biggest shape? Sometimes it is not in the center but perhaps at the bottom or one side. Is there a strong animal shape?

If the design is one filled with ribbon shapes crossing over one another, it may be almost impossible to find the beginning—a total puzzle!

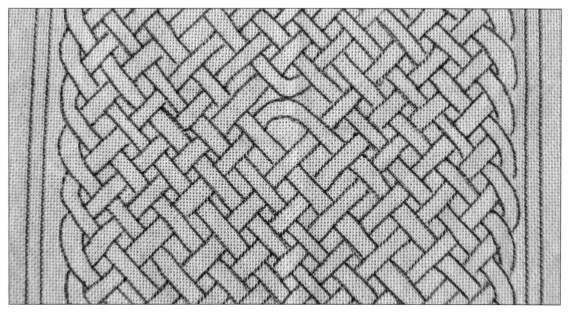

Where to start?

A HOUSE AND ITS ROOMS

I have found the easiest method is to think backward. What do I mean by that? Let's use the analogy of a house as an example. Our house is a large structure with several rooms. In each room there are furnishings; the room may have pillows, or there may be pictures on the wall. A Celtic design is very similar: there is the overall design, but within the design, there are spaces like rooms. As well, in these spaces there are furnishings, maybe the feathers on a bird or a knot tucked in a corner space. Similarly, we can approach any complicated design from the outside in—we need not be concerned with finding the center to achieve the end. As long as one room or space can be identified, we can follow the path to the other rooms and work at deconstructing those.

Let's take a look at one design to see how we can deconstruct it and what happens along the way, using one of Dave Rankine's earlier designs called *Centred*.

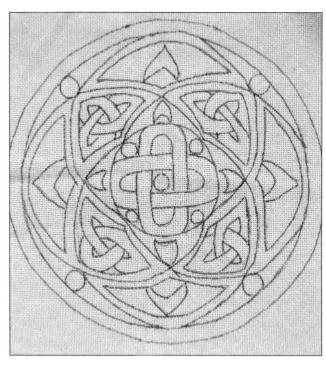

A busy design is like a house with many rooms.

At first glance, it may look so busy that it is puzzling where to start! This house has many crowded rooms. Looking at the house, it is easy to see it's a large circle, with the most easily recognized room the center knot. Look closely and it becomes clearer that the knot is contained within a small circle.

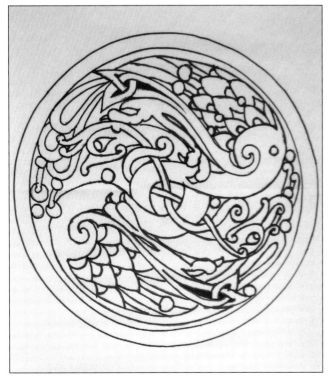

Where is the strongest point in the design? Take time to identify the main room.

Decoding a design starts with identifying the rooms. Finding the largest room first helps.

So, we have identified the house and its center room. That was not so hard, so let's proceed. Working from the center out, looking for the next biggest space (and ignoring the furnishings), we discover there are triangles that unite to form an intricate pattern.

Once the main room is found, branch out and seek the smaller spaces.

• •

Treat each circle or triangle as a closed section, breaking down the larger sections into smaller, less confusing units. Now is the time to choose the main color for the room/space. Take time to get to know the space. Will each space have the same color chosen for the sake of unity? Remember, they will be divided by the black outline, but will the outline show if a dark blue or purple is used? If you want the background to be hooked in one color, a lighter color might be best. Perhaps each space will be hooked differently to help move the colors throughout the design.

Once the background color has been picked, begin to focus on the furnishings. All together they become one.

Discovering these basic foundation shapes has put you in direct contact with the ancient Celts; you have traveled back hundreds of years without leaving your armchair. It is humbling to view the surviving devotional manuscript title pages that started out with a simple circle and ended with a page filled with hundreds of hours' worth of hand-drawn designs.

USING COLOR TO MAP A DESIGN

Fabric markers are worth the expense for this tricky step, deciphering a ribbon design. But before you begin mapping out the design permanently with markers, try using colored chalk. Using a paper pattern guide will save you from future headaches. Chalk is easy to wipe away if you've made a mistake or wish to change the color. Start with one ribbon on the outside and lightly trace the pattern with your chalk, stopping and starting at the overpasses and underpasses where necessary. In most cases, the ribbon will take you right back to the beginning, but don't be discouraged if it doesn't—some ribbons never return. Proceed, treating each ribbon individually, and eventually you will have mapped out your hooking pattern.

Using different colors will help map out a ribbon design.

• •

Your color placement may be different when you hook it; at this point, you are only trying to discover which ribbon goes where. Later, you can play with creating endless color variations or themes. After you successfully separate each ribbon from the other, you can retrace the design on fresh paper to begin the final color planning.

HOOKING CELTIC RIBBONS

There are two ways to hook ribbon designs. The simplest method is to hook them as they are drawn. What does this mean? Often when an artist is creating a design freehand, there will be variations in the width of the ribbon, as was the case with ancient manuscript artists. So, you have the opportunity to follow the artist's hand and hook them as they were drawn. Hook the outline first, then fill in the ribbon with the appropriate colors, using however many strips may be required. In this method, the ribbon will be narrow at some points and wider at others. This works well when hooking illuminated letters—it gives the design an authentic aged look.

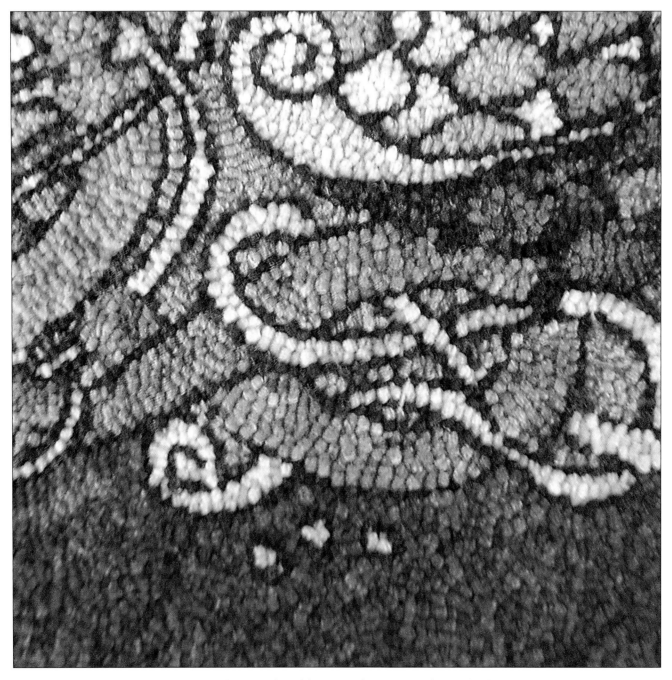

Following the artist's hand when hooking produces a unique design. Notice how the yellow ribbon becomes larger and smaller as it twists throughout the pattern.

The second method, called a regulated ribbon strip, requires some analysis. In this case, only one side of the ribbon outline is hooked. Then the ribbon is hooked, lining up the strips and using the same number of strips throughout. Then the other outline row is hooked.

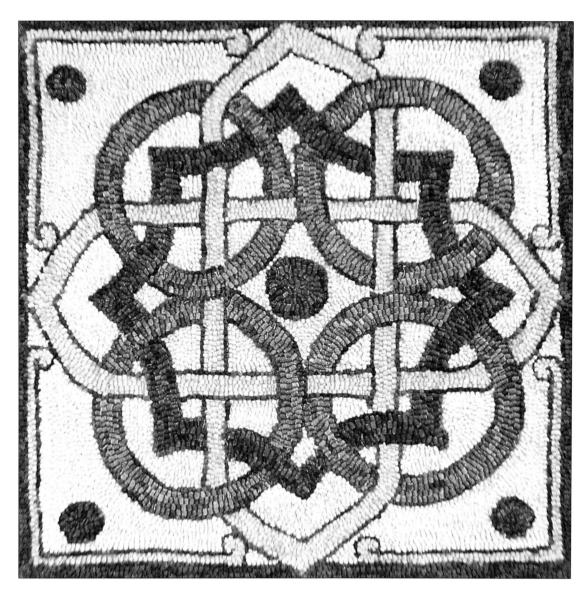

To hook a regulated ribbon design, the same number of strips must be used.

In this method, some thought must be given to where the ribbon ends and starts because not all the ribbons have been outlined or hooked. Hooking in this manner works very well if you want a more uniform look and if the design is made of only ribbons. This style should not be used for ribbon crossovers in letters or other designs. Hooking all crossovers using the same number of strips could result in an eye, leg, or some other detail getting lost due to the increase in ribbon width. Or the detail may lose definition because it's too narrow.

Slow Cooker Boneless Leg of Lamb

1 tsp. salt

1/2 tsp. black pepper

4 sprigs chopped fresh rosemary or 1/2 tsp. dried rosemary

1 Tbsp. Dijon mustard

2 Tbsp. orange marmalade

2 Tbsp. olive oil

1 onion, sliced

1/2 cup vegetable stock

1.5–1.8 lb. boneless leg of lamb

1-2 Tbsp. flour

Roasted carrots and potatoes for serving

Preheat the slow cooker for 20 minutes. In a medium bowl, mix together all the ingredients except for the lamb. Place the leg of lamb in the slow cooker and pour its mixture over. Cover and cook 9–10 hours on low or 4–5 hours on high. When it's done, remove the meat and tent with foil while making the gravy. Strain the liquid and bring to a boil in a small saucepan over medium heat. Whisk in 1-2 tablespoons of flour, additional vegetable stock as needed, and stir until it reaches gravy consistency. Slice the lamb and top with the gravy. Serve with roasted carrots and potatoes.

This recipe is one of my family's favorites. I throw this together in the morning when I know there is a busy day of dyeing ahead. Serve with potatoes or rice and vegetables.

⑤ Celtic Animals

May those who love us love us;
And those that don't love us,
May God turn their hearts.
And if He doesn't turn their hearts
May He turn their ankles,
So we will know them by their limping.

- Scottish Blessing

Compared to some other forms of hooking, Celtic designs present unique challenges. Looking at a primitive, floral, or pictorial design, it is easy to spot the main focal point or design quickly. A primitive horse, a star, or a flag are not hard to spot; the same can be said for a rose in a fine-shaded design or a house in a pictorial. Finding the main focal point for many Celtic designs, both ancient and modern, is not quite so easy.

Once we start to look at designs with beasts, all reason and sense of order disappear. First of all, Celtic animals live in a world of their own, created only to fulfill a need for the artist, which may have been devotional or to pay homage to a warrior. Secondly, many of these beasts bear no resemblance to any real animal, living or dead. There are animals we are familiar with, such as dogs and birds; however, a Celtic dog may have two heads, one leg, and no body. A bird may possess two necks that intertwine around one another, with each section a different color. In fact, each individual feather may be a different color, leaving us searching for an order that does not exist. Often the creatures seen are zoomorphic, meaning they start as one animal and turn into another, such as a lion with a man's head or a wolf with a bird's wings.

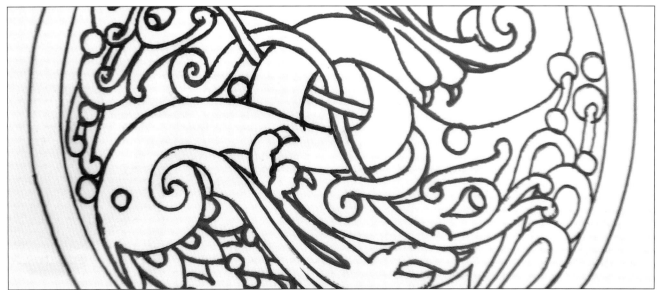

Finding the two rooms can be a challenge. Take time to analyze the design.

The ancient Celts lived in a superstitious world, filled with beliefs where every creature, rock, and stream—indeed, all life around them—had a god and life unique to that particular item. Celtic art often reflected these beliefs, giving homage to the unseen spirits. While their art was both highly spiritual and decorative, it was often created to fill a space, such as on a sword handle or a vase. In decorative gospel books, where the inspiration for most Celtic hooked letters originates, the focus was on devotional themes of Christianity.

When Christianity arrived, excellent examples of filling a space abound. *The Book of Kells* and other books of devotion have entire title pages called *carpet pages*, which are filled from margin to margin, with no space left empty. These carpet pages were seen as devotional art and could be worked by many different artists over many years. (As hookers, while our backing is filled with individual loops, we are not forced to fill every space with shapes and can allow the background to remain empty and clear.)

DECODING CELTIC ANIMAL DESIGNS

Faced with one of these zoomorphic designs, it's no wonder many students respond with this comment: "It makes no sense!" They are right, and it can be daunting to be faced with one of these for the first time. But these unique designs can be decoded, as we learned in the previous chapters. Let's take a look at another of David's designs.

First, we see our house—one large circle. Can you see the rooms? There are two large shapes in the center of this house that stand out. If we trace them on paper, what will we find? Remember, we are not interested in any of the furniture yet—leave out the smaller bits and just trace the large shapes.

Tracing shows us two birds as focal points.

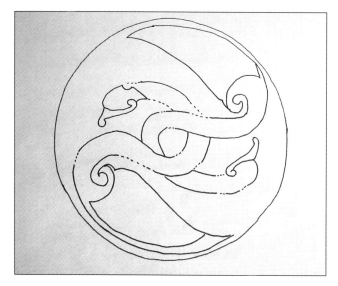

Once the design is traced, it is easy to see the two main rooms.

The dotted lines indicate where another part of the pattern overlaps. If the design of two birds is not clear, try using a different color for each bird. The fact that the necks are intertwined may be confusing at first, but once colored in, the shapes should stand out as two separate birds. We are not interested in the smaller bits yet.

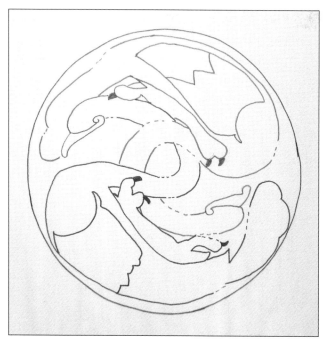

The design becomes much easier to understand when traced using two different colors.

Once you find the main design, reposition and continue tracing the next part of the design, in this case, the tail and legs. Again, the dotted lines indicate another overlap.

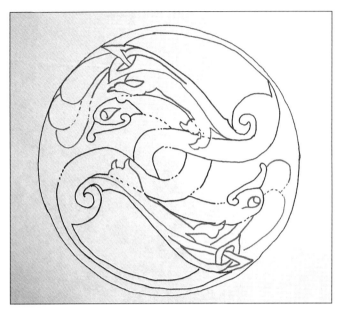

After the main design is mapped out, it's
time to start adding the furniture.

• •

Don't look for an even number of legs: there may only be one, or possibly three, and sometimes none at all! Do pay attention to the claws on the ends of the legs, which can sometimes help to orient the direction of the legs.

Take time to analyze what you have done. Are your rooms clear? Does it make sense to you now? If not, go back and study the first step. Have you followed the main part correctly? Perhaps you got confused with an overlapped tail or ribbon section?

Now is the time to understand your pattern. If it is not making sense, try coloring the main portions. This helps the eye distinguish what the brain is struggling with. You will get there.

After you have mastered the main elements, it's time to start playing with your colored chalk or markers. Be sure to take time out to rest your eyes and brain if you are feeling muddled. It's amazing what a rested brain can figure out after a little break.

Using a bird as an example, let's proceed. The main elements of the design have been clearly established: the body, legs, beak, feathers, and claws. And any ribbon crossovers have been plotted out. Choose the strongest color you are using for the body of the bird, choose two complementary colors for the feathers, and one more color for the legs. The beak and any circles can be in poison colors to bring a little flash to the pattern.

If the colors being used for the bird are strong, intense jewel colors, a soft, muted color will work best for the background. Of course, if the bird is hooked using soft, muted colors, choose a strong background color. The focus of your mat should always be the main subject, never the background. Choosing a color opposite in strength from the color of the subject should make the main motif stand out clearly. If a border will be hooked around the design, look for one of the stronger colors to help ground the mat. A lighter color border will give the illusion of the design floating above the background.

Figuring out Fancy Tails

Let's follow another design from beginning to end. In this case, it's David's pattern *Fancy Tails*.

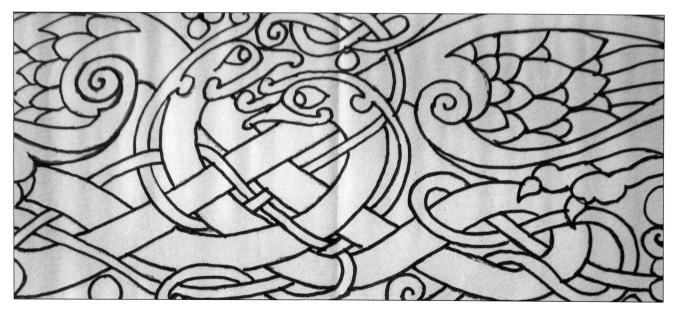

Looking at Fancy Tails *to see where to begin.*

First, we will locate the main rooms and map out the twists in the birds' necks. Using two colors helps us to see the birds as two distinct creatures.

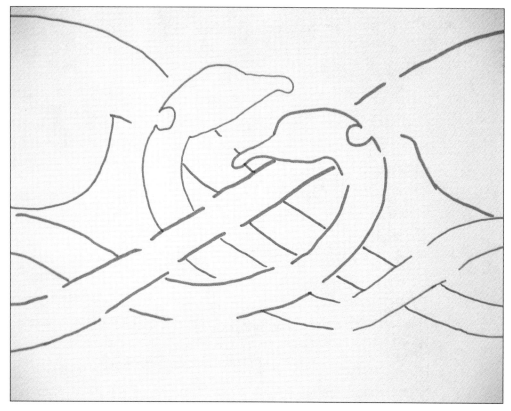

If it doesn't make sense, try again using two colors.

Once the necks have been clearly established, the legs and feathers can be added—we are filling the rooms.

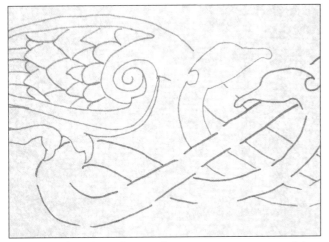

After finding the main rooms, we can add the extras.

• •

You should now be able to see different elements that in turn make up the whole design. Once the pattern is clear, it's time to choose the colors.

Wanting to explore a particular color theme, I decided to introduce two color values when hooking the two birds and add two different background colors. This is not something done in the more traditional Celtic art, but I believe art is constantly evolving, and I wanted to see if two different background colors would add more depth or movement to the piece. I also wanted to play around with the mirror images so often seen in the gospel carpet pages where two birds, usually peacocks, mirror color and shape around the edges of designs. I chose blue and green as the colors to mirror because they are so closely related on the color wheel. I knew the birds would be one of the stronger, darker colors. With that in mind, I placed the lighter feathers next to the body and allowed the color to walk outward toward the tail. A light next to dark is always a good choice to create a striking contrast. Hooking with darker values next to the darker body color would not have been as striking, with

little difference showing between one value and the next.

I wanted the legs of both birds to be the same color to bring some unity to the piece. I originally had them red, which worked for each bird but clashed horribly when I hooked the lighter background color. After trying a number of different colors, I went to my go-to color when all else fails—I hooked them in purple. I was pleased with how that looked, both against the two birds and against the light background. I was surprised by this; I had placed all the colors next to each other before I started hooking and they appeared to work well. But once hooked, it was clear they did not, necessitating a change. Sometimes we must acknowledge that changes are necessary for a more harmonious design.

I wanted a lighter background color for the center so the stronger bird colors would stand out, and I was pleased with what happened in my dye pot. But I also wanted a stronger background color for the outside of the mat to help ground the entire piece. After some experimenting, I created a formula that worked well with both birds, gave the movement I desired, and anchored the outside of the pattern.

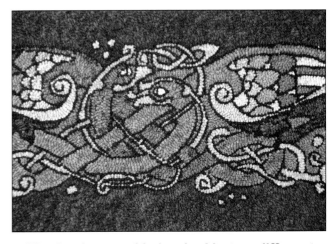

The background is hooked in two different colors: darker on the outside and lighter in the center. The bird feathers are hooked in values of the same color.

• •

Shepherd's Pie

2 lb. potatoes, peeled and cut into quarters

1/2 cup milk

3 Tbsp. unsalted butter

1 lb. ground meat, either pork, beef, or lamb

1 large onion, finely chopped

2 carrots, finely chopped

1/2 cup frozen peas & corn

1/2 cup vegetable broth

1/4 tsp. ground cumin

1/4 tsp. dried parsley

Salt & pepper

Preheat oven at 425°F. Cook potatoes till soft; mash, and add milk and butter. Stir until you reach your desired consistency. Brown the meat with the onion in a large skillet over medium-high heat. In a small saucepan, cook the carrots in enough water just to cover. Cook until the carrots are tender, 5-6 minutes. Drain the water and add the frozen peas an corn and heat through. Add the broth and spices, then add to the meat mixture and combine. Place the meat and vegetable mixture in a shallow pan. Use an 8″ x 8″ pan if you want it tall, or 9″ x 13″ if you need more servings. Top with the potatoes. Bake for 25 minutes or until brown. Scoop and serve.

This is my favorite busy-day recipe—and the leftovers are yummy too.

⑥ Illuminated Letters

*May your troubles be less
And your blessings be more.
And nothing but happiness
Come through your door.*

- Irish Blessing

The pinnacle of Celtic rug hooking is the Illuminated Letter. Everything you have learned up to this point will be put to use in these beautifully designed patterns. Here we have Celtic knots that twist and turn, closing corners or opening letters. Here we have geometric spirals with mathematical precision. Here we have ribbons that gracefully entwine and caress the creatures of each letter. There are points that shout "Look at me!" and circles that say "Can you find me?" In the center of it all is a fantastic bird! However, even though the bird may be one of the motifs, you still must search to find and identify all of its parts. Where is the head amongst all those twists and turns? How many legs are there? Is there more than one bird? Nothing can be taken at face value in Celtic art.

Why were such fantastical letters created? Certainly, Celtic art had been evolving for hundreds of years without letters. Whimsical creatures, knots, and ribbons were standard in the art, but letters were not. The Celts were an oral society, where Druid storytellers and poets were responsible for preserving the laws and history by memory. The farmer or warrior Celt had no need of a written language.

It was not until Christianity migrated from Europe to the British Isles that the written word gained importance. Monastcries appeared, and monks spread throughout the region, converting the pagan Celts and spreading the gospels. To aid them in this calling, the monks copied the gospels creating large, intricately designed and jewel-covered books. Many of these talented monks had been Celtic craftsmen; consequently, their artistic talent blended with Christianity and created these outstanding works of written devotional art. Although these were sacred texts the artists labored over, they did not always stay somber. In fact, these ancient manuscripts are filled with humorous decorative art—such as men pulling each others' beards—although misunderstood or incorrectly copied text may have led to some of the more humorous aspects of both text and images.

Illuminated letters were drawn to cover what was called the carpet page, a page often decorated with only one large letter that frequently was covered in rare gold leaf. The term "illuminated" referred to the shimmer of gold used in the text. A medieval book of illustration was not just a book of devotional art; it was a visual tool as well, created to impress the illiterate masses. Books played a central role in monastic ceremonies; they were often considered talismans with holy powers and were displayed on the altar along with other religious artifacts.

HOOKING ILLUMINATED LETTERS

These large letters, a thousand years later, are perfect subjects for hookers today. While we may not study the gospel in great detail or use gold leaf, we can create outstanding mats that will become precious heirlooms.

Just as there are varying opinions surrounding the Celts' lives and beliefs, so too are there variations in how these letters should be hooked. One school of thought is to hook them in the colors found today in *The Book of Kells* and other ancient manuscripts. These are muted, somewhat darker, brooding colors. Mats hooked in this manner have a serious, no-nonsense feel to them, as if they are saying the subject is a solemn one and must be afforded the respect due to an ancient work of art. The second approach is to hook the letters as they may have looked hundreds of years ago. This method would reflect the colors used at that time—colors that were bright, vibrant, and full of life. After experimenting with both methods and doing extensive research, I have chosen the latter. There is one thing that becomes clear when reading about the Celts: not only did they love life and fighting, they also loved color. They used color on their bodies, in the jewels they wore, and in every aspect of their lives, from the mundane to the ceremonial.

So, let's have some fun! We'll look at two letters, and I'll share my process for planning and choosing colors for an illuminated letter.

For our examples, we'll use two letters, an *A* and an *L*.

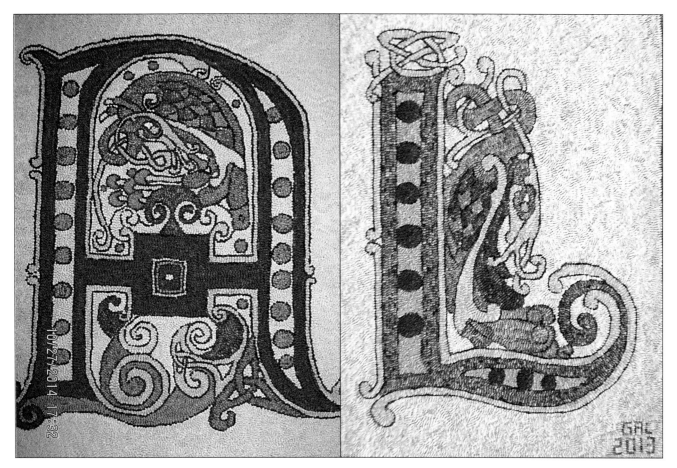

| The Celtic letter A. | The Celtic letter L. |

The Letter A

Starting with the letter *A*, I first mapped out the main letter and then the bird.

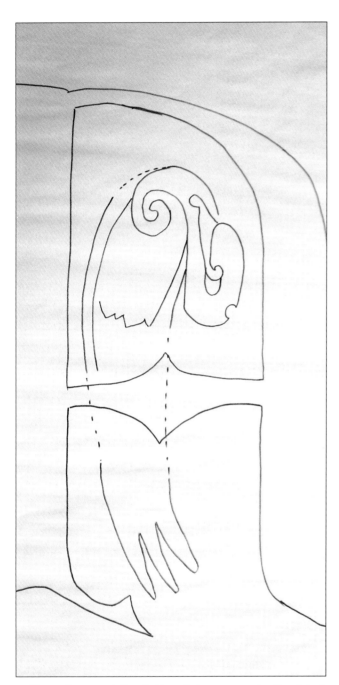

Mapping out the letter A to separate the bird design from the letter.

• •

After I knew where all the twists and turns were for the bird's neck and had the body clearly defined, I started thinking about color.

Choosing a background color is hotly debated among hookers. One view is to choose that color

first and work the other colors around that choice. The second opinion is to choose it last. Generally, I fall in the latter category; I usually find the vellum color works well, so I don't spend much time thinking about the background.

That was the case for the letter *A*. I knew that vellum would be my first choice and that this mat would be hanging. I hooked this mat for one of my sons, who owns a large, black Labrador dog, and I had no intention of this becoming a dog's resting place after a roll in the mud! The finished mat would be given with a hanger.

I approached the letter *A* the same way I approach all letters—find the main focal point (the bird), and trace its twist and turns. If I don't have a paper pattern to work with, I will map this

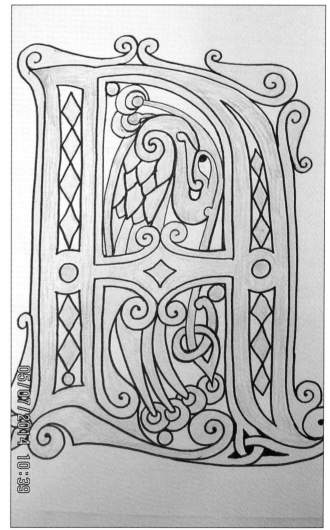

• •

out on the background material with markers. In this mat, I wanted to use a deep red and a pretty light blue. Red is an accent color in my son's home, so using this color was a good choice because the rug could be hung in a number of different areas.

Although light blue was only going to be an accent color in the mat, it was so strong that I knew I would need to tone it down with the surrounding colors. I chose a darker blue for the bird and was going to add the light blue color in the feathers; however, the darker blue was too overpowering. I wanted to make sure the mat was balanced, but using the light blue at the top of the mat would have made it significantly lighter than the bottom, giving it an unbalanced feel. I played around with the red that I used for the main letter, but it was too heavy beside the darker blue.

I decided to use a brighter red along with a lighter green; they could hold their own both against the light blue and the darker red. The bottom of the mat needed to be able to balance the top, so I needed to use strong colors that could compete, and I wanted to pull the green down to the bottom. I used a rich purple to hold the bottom colors together. Purple works well with any of the color combinations that I use when hooking Celtic mats. It is my go-to color when searching for the link needed in a particularly tricky color plan.

The Letter L

When I started color planning for the letter L, I knew the main letter component would be blue, and I had a magenta that I had been saving for the right project—this was finally the perfect project. Blue is one of my favorite colors and would match my furnishings, and I knew the magenta would work well with the blue.

The bird's color required some thought. Initially, I intended to use purple and green, but with such a large amount of blue already chosen, the mat would have been duller than I wanted. Playing with colored markers helped with this decision. It's much easier to color in a space than to hook, then unhook and rethink.

I was concerned that using green and red would give the mat a Christmas look, and I didn't want that. But by adding the orange to the feathers and with the strong magenta close by, I avoided the holiday feel. And I like to add some yellow in every piece as a way of staying true to my Celtic ancestors and to connect with the art from *The Book of Kells*. I hope the monks were as happy adding their gold leaf as I am adding my yellow!

That left the background color. I didn't want to use my favorite vellum-colored wool because this piece would be used on the floor. It might be in a high traffic spot, and the vellum would show dirt more than another color. I played around with a light blue, which I quite liked, but my furnishings have blue in them and so do my drapes. Too much blue. I tried a few shades of a light dusty rose; while that worked well with the blue, it was a nightmare with the red and orange. Finally, I settled on a spot-dyed green. I was initially reluctant to use this wool because it is not generally used for Celtic mats. In this case, it worked beautifully and was the right choice, discovered by the trial and error of experimenting.

Design Note: *While I have hooked many Celtic designs using a limited color palette, I still take time to play. I may move and change colors around many times to achieve the harmony I want. Don't rush when planning your project. Take time to know the individual spaces and how they will relate to those next to them. Remember the analogy of your house and its rooms. Get to know the basic room plan before choosing the furnishings.*

The Letter D

Take a look at two D's side by side—here we have a before-and-after color planning illustration.

Before any planning is started, the letter appears to be a complex jumble of lines, shapes, and circles. It's hard to find any creature hiding, let alone search for feathers and claws or a tiny eye. But if you take your time and start with the larger house plan (in this case, the main body of the *D*) you will be able to plot out the floor plan.

Some of the colors will change as I start hooking this piece, and that is to be expected. A pink I intended to use clearly won't work with the red. It would have been less confusing if I had played more with colors on a paper copy first. You will have the opportunity to do just that when using David's patterns. Be mindful, though, that you can change any color, any time.

Look at these Illuminated Letters as brain exercises—just one more way rug hooking can enhance your mental health!

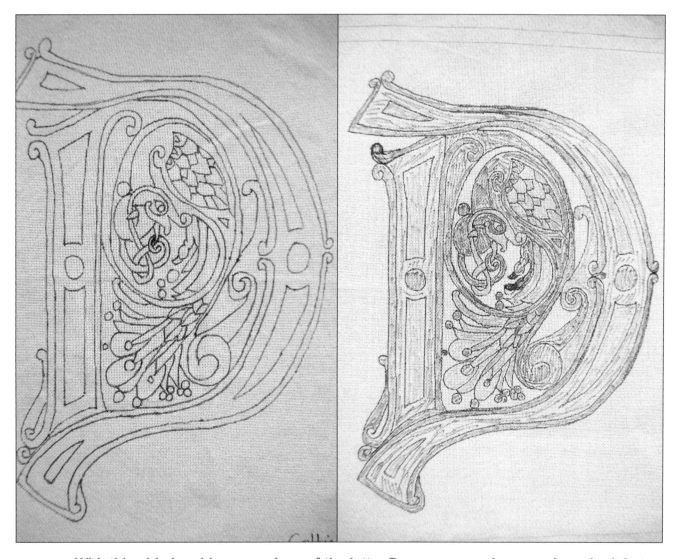

With this side-by-side comparison of the letter D, you can see how much easier it is to identify the parts of the design. On the rug warp, the pattern is a bit confusing, and it's hard to see the main body feathers and separate the tail feathers. Once colored in, each section can be identified more easily.

Illuminated Letter Details

When commencing any letter, the first task is to hook the outline around the eye, then the beak (all letters have these), and then move down to outline the body. I recommend this for a number of reasons. The eye is one of the smallest sections on the mat, and it is easy to lose. It is also a good way to get in touch with the mat. Once an eye is hooked, there is life! The beak is also very small, and it can take over and become unruly if hooked too tightly or packed. I have found that hooking a holding line around the outside of each section keeps the eye and beak from spreading.

Hooking the background colors around a small space will help keep the shape of the smaller sections under control.

One of the advantages of color planning is knowing which color will be next to a particular section, such as an eye; the holding line can easily be hooked because the color is already chosen.

Once I have life in the mat and have hooked both the eye and beak securely, I look for the next smallest section, which is generally the feathers; those I treat one at a time. I hook the outline, then I fill in the feathers, hooking in the direction of the feather.

Always hook in the direction of the feather.

Do not pack in too many loops, or the feathers will become distorted. Remember, a holding line can be hooked around the feather, using the color of the feather next to the one you are working on.

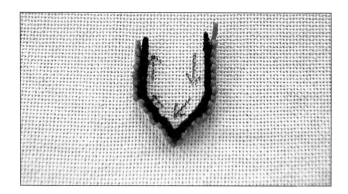

A holding line helping to shape a feather.

After the bird's main body is hooked, I move on to the legs and claws. These change in number from one design to the next, with some birds owning two or three claws and others without any. I fill in the claws with the outline color, but for the legs I designate another color. As I do everywhere possible, I hook a holding line of an adjacent color.

Hooking Tip

Take time to rest and check your work. Sometimes, when we are engrossed in a particular spot, the whole picture gets lost. We can lose the shape of the bird's body by focusing on each feather. Step away and look to see how your work is relating to the mat design as a whole.

Pay attention to the background between the bird's body and legs. I suggest filling it in as you go. Leaving tiny bits of background until later generally results in these spots getting lost and/or the hooker becoming very frustrated. If you have a paper pattern or take a photograph of the pattern before you start, refer to it often to make sure you catch them all. They are just as important as the larger bits—and sometimes more so. A small center lost on a knot will cause the whole knot to look chaotic, losing the proper flow. The same can happen when a small background section has been left out around a bird.

Hooking Tip

If you have consulted your pattern and realize that a tiny bit is lost, turn the piece over. It is amazing what jumps out at you as you view the design from the back. Carefully push a toothpick from the back to the front to mark where there are missing loops. When you turn the piece over to the front again, the toothpick is easy to spot, and the loops can be hooked, the background filled in.

Always hook in the flow of the shape you are hooking. Hook along the length of the neck and body, not side to side. The key to all Celtic designs is in the flow! One area must flow as it twists and turns to engage the next section with its twists and turns.

Following the proper direction will give a uniform movement to any design.

Most letters have points somewhere in them, and it's important to pay attention to those points. Whether you choose to start and stop at the point or begin hooking partway up the point, as discussed in chapter one, be sure to keep the point sharp, not rounded. The objective when hooking Celtic letters is to have a nice directional flow throughout the letter, with crisp outlining, sharp points, and clear, exact circles. If a circle is included in the body of the letter design, as it is in the letter *A*, hook the color next to it completely around the circle.

This will help the circles stand out much better than if the black outline is touching the sides. If the circles are accents placed randomly throughout the pattern, it is not so critical to have them surrounded; however, I still try to hook a holding line to help each circle hold its shape.

Hook the main letter area following the length of the letter, being sure to hook a holding line so the outline will remain clear and sharp.

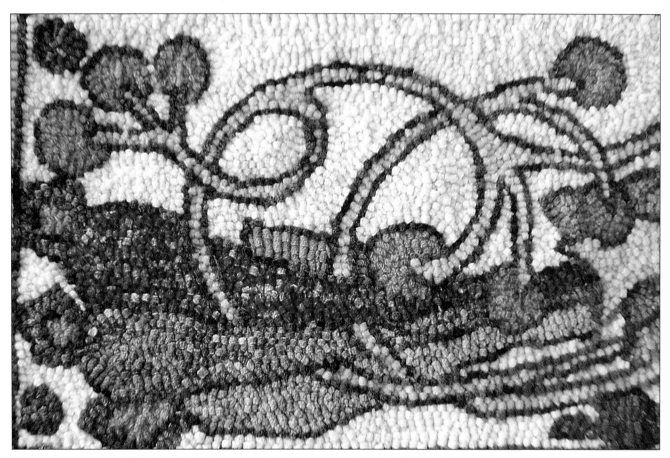

Hook the background color around each circle for a crisp shape.

The main background of the piece can be hooked using lazy swirls. I usually measure 2″ out from the farthest tip out on each side and draw the anchor line there. Before hooking too far out when hooking the background, hook this anchor line around the entire piece. This line will give you something to aim for and maintains the shape of the mat. It is surprising how quickly the space from letter to edge can be filled. Always hook from the letter to the outer edge; this will help with the tension and prevent the mat from bubbling up, which can happen when working from outside to center.

If you are including a beauty line in your design, now is the time to mark and hook it. Measure approximately 1″ in from the outside anchor line and draw a line all around the mat.

Marking in the beauty line.

Hooking in the beauty line.

I hook my beauty lines in the main color I used in the letter. The outside few rows of hooking between the beauty line and the edge of the rug can be hooked in a larger cut, such as a #5, which gives a firm line to hold the whipping when finishing the edge.

Microwave Custard

1/2 cup sugar

2 Tbsp. cornstarch

2 Tbsp. flour

1/4 tsp. salt

2 cups milk

2 eggs, beaten

2 Tbsp. butter

1 tsp. vanilla

Whipped cream and sliced strawberries for serving

Combine the sugar, cornstarch, flour, and salt in a large glass bowl. Add the milk and stir until mixed. Microwave on high for 7–10 minutes, stirring every 2 minutes until smooth and thickened. Slowly add 1/2 cup of the hot mixture into the beaten eggs. While whisking, so the eggs will not curdle and have a creamy, smooth custard. When mixed, add back to bowl. Microwave on high again for 1–2 minutes. Add the butter and vanilla and stir to combine thoroughly. Chill the custard for 2 hours or longer. Pour into individual dishes and cover with plastic to prevent skin from forming. Garnish with whipped cream and sliced strawberries.

After all the hard work in this chapter, a nice dessert is in order. This is quick to whip up in the microwave and is good on its own or spooned over fruit or cake.

 # Finishing Your Celtic Project

May the road rise to meet you.
May the wind be always at your back.
May the sun shine warm upon your face.
May the rains fall soft upon your fields.
And until we meet again,
May God hold you in the hollow of His hand.

- Irish Blessing

For most hookers, finishing a mat is perhaps the most tedious step. The hours of thought over choosing which design to use, the agonizing over color placement, the fiddling with strip size, and the hours and hours of hooking have produced a beautiful mat. However, there are a few more steps before your work of art will be ready for the wall or floor.

Your project needs to have finished edges to give it a professional look and to avoid unraveling. This process is referred to as whipping and is done by covering a cord with yarn, and then covering the raw edges on the backside or underside of the mat with twill tape. When finished, the mat will not have any unsightly raw edges of backing showing and will look neat and tidy both on the front and back.

PREPARING THE MAT

Before you start, give the mat a final visual check. If there are stray threads showing, perhaps caused by the wool being pulled through the backing, snip them off, being careful to not cut into the loops. Are there any tails that need to be trimmed? Are there any loops that need to be pulled higher or snuggled down lower? Turn the mat over to check for empty spots; use the toothpick method to fill those gaps. Are there any crossovers or twists that should be taken out and re-hooked? This is the time to fix minor problems.

Most mats will have excess backing material around the perimeter that must be removed before the final finishing.

Once hooking the mat is completed, it's time to remove the extra backing.

The best method I have found is to place a piece of twill tape along the edge of the mat and mark the distance out on all four sides.

Place twill tape beside the finished mat and draw a line along the outside of the tape. I then zigzag around the mat on the inside of this line.

I then zigzag around the mat inside this line.

Remember to zigzag around the line before cutting off excessive material.

Everything outside of this line can be cut off and discarded.

Now it is time to press the mat. Pressing will flatten any sections that may be too high because of packing the loops too closely, and it will even out the loops and give a unified look to the mat.

Place the mat on a covered surface or ironing board with the back of the mat facing up. Set the iron to the wool setting. You will need a clean piece of cotton fabric that can be thoroughly soaked with no danger of any color bleeding out. I use a clean cotton tea towel, one used for drying dishes.

Place the damp towel over the mat, place the iron on the towel, and remove your hands! There is no need to press down or push the iron around. Pushing down too hard will cause the loops to shrink, and the result will be a mat that is not soft and plush but hard and lifeless. Pushing the iron around will distort the loops and may cause the mat backing to become uneven. I generally count to ten then lift the iron straight up and place it gently down on the next section. Do this until the entire mat has been pressed. Gently turn the mat right side up, rewet the cloth and press in the same manner until all the mat has been pressed. Let the mat rest overnight. If it must be moved, do so gently and make sure it is flat and not pulled out of shape. Some sections may pop overnight because of packing; simply repeat the pressing procedure. It's very rare that a puffy mat can't be pressed into shape. If the mat simply will not behave and flatten, check to see if there is an area where some loops can be removed. Packing too many wool loops is a common problem for many hookers, so you are not alone if this happens. Remember that not every hole in the backing needs a loop!

WHIPPING THE EDGES

After the mat has dried thoroughly, it is time to whip. A good finish will have all the whipping threads going in the same valley or straight line on the front and back. It is not so hard to achieve on the front, but it is often easy to lose the line on the back. I solve this by placing the cording underneath and wrapping the background material tightly around the cording. When this is done, I gently push a rounded needle, like a darning needle, from the front to the back and mark with a pin where it has come through.

Wrap the backing around the cord and stick a pin through to the front. Count the valleys from the pin placement to the design edge, then draw a line to follow when whipping.

Cover the cording completely and snugly with the backing. I then count the valleys from the mat edge to the pin and make a pen mark. I count the same number of spaces on each side and draw a line around the whole mat. This gives a very clear line to follow for all the whipping stitches on the back.

The inside line will be the one to follow for the whipping.

As you well know, there are varying opinions on most areas of hooking: what backing to use, how to hook a point, what type of frame or hook to use—and the use of cording is no different. There are hookers who never use cording and simply sew on the twill tape. There are others who curl the excess backing into a tight roll and whip over that. I have tried a few methods and always come back to the cord. It is certainly the method most often used by the hookers in my area, and there is probably a traditional aspect to this.

The size of cording used depends on the project. A thick 1/2" cording would never be used on a small trivet, nor would a tiny cording be used on a large floor mat. A hooked Celtic letter would usually have a 3/8" cord. Check with your local shop or other hookers for advice if this is the first project you're whipping. There are many other creative methods for whipping, such as using wool strips or silk fabric strips, to name just a few. They all work well, and it will take some experimenting to find the one you prefer. In fact, not all mats will be treated the same—a pillow will not require twill tape, for example—and framing a project will necessitate a totally different approach. Experiment, and you will find the method you like best.

To begin whipping, leave a small section of extra cording free at the beginning; this will not be covered over by the yarn. It is a good idea to cover the end of the cord with tape to keep it from unraveling.

Leave a bit of cord free when you start whipping.

This will be matched with the end of the cord once the whipping has gone around the entire mat. So, yes, the beginning will be the end! Never start whipping at a corner. Make sure you are approximately 2″ from the corner to leave enough material to form the miter needed. I recommend using pure wool, not an acrylic or blend, which can stretch. A nice finish to any mat is to use a color found in the mat, generally one of the main colors. I most often whip using the same main color that was used for the letter. My second choice is black, as that is color used for all the outlining. Either will work, but don't introduce a color that is not used somewhere in the mat. All colors of the mat must flow together to create a harmonious finished design. The addition of an isolated color will be jarring.

Don't use a piece of yarn that is too long. It seems like a good idea—it would mean fewer starts and stops, and it would allow you to whip a longer section. But, in fact, the wool twists and tangles, necessitating many stops to untangle. It is also harder to keep an even tension with yarn that it is too long, which will cause the whipping to look wavy and uneven—a not-very-pleasing finished look. I suggest cutting a piece of yarn about 30″ long and then doubled, so two strands are pulled through at the same time. Don't knot the end because it will cause a bump in the binding edge. Pull the first strands up from the bottom so the tails will be hidden with one tail longer than the other to avoid any large bumps. The two tails will be covered eventually with the yarn whipping.

Keep one strand longer than the other to avoid unevenness as you whip.

Keep the strands under the same tension: don't pull too tightly or leave the yarn too loose. I run my fingers over the wool yarn from time to time to make sure the yarn is flat and is not building up in one spot more than another. I use the yarn doubled and skip a hole, and find this works well. I don't have to go in every hole as I would if using a single strand, and the double yarn strands cover the empty hole nicely. I take the needle up through the outside row of hooking to avoid leaving one white line showing. Skipping holes makes the job go a little quicker!

Many hookers whip using one single strand of yarn. Start the thread a short distance ahead of where you are beginning the edging and whip over it as you proceed around the mat. Be sure the backing doesn't show through.

Take care at the corners. It's not only beginners who have to fiddle from time to time to get a corner just right. I miter the corner and pin it to keep it in place. A few stitches will help to keep things in their proper place too. For the beginner, it is often easier to stitch than to work around a pin. The lines that were drawn act as a perfect guide.

The line drawn for the cording will help establish the corners for whipping. If done properly the cording will meet nicely at the corner.

The corners are usually mitered to avoid any large lump that would occur if one side were folded over another. A mitered corner is much easier to whip through than a folded one. It will be necessary to go through some of the same holes a few times as you change direction.

When you reach the end of the yarn, thread the needle back into the whipping you just finished and cut the yarn, making sure to cut the tails at different lengths.

When the end of the yarn is near, gently push the needle back through the previously whipped stitches.

Don't end your yarn at a corner. A corner is difficult enough to do without trying to stop and start a new length of yarn, and you don't want any yarn to start unraveling from a corner not whipped correctly.

As you whip, don't hurry—take your time and relax! After all the hours spent hooking a masterpiece, it's important to have the finishing match the work. I place the mat on a table when both whipping and sewing on the twill tape. A small mat, of course, will not have much weight, but the larger Celtic letter designs can be quite weighty and are warm to have draped over your legs on a hot day.

Sew twill tape on the back of the mat to cover any backing material and to protect what is there. It hides the yarn tails that might be showing from whipping, and it provides a professional finish. When measuring for twill tape, allow an extra 1 1/2" for each corner. Use a sharp needle and regular sewing thread the same color as the tape. Many a mat has lost a ribbon in competitions because of poor finishing. Time spent learning proper finishing techniques is not time wasted.

Sewing on the twill tape is a two-step process: first, sew the edge close to the yarn whipping, then sew the inside edge onto the mat. Don't start at a corner, begin on a side.

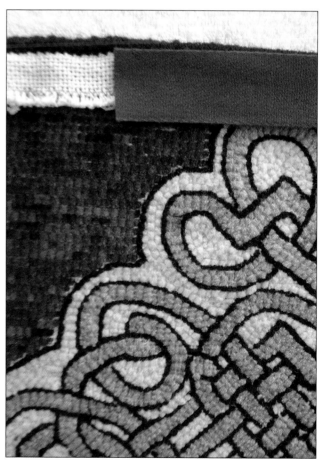

Never start the twill tape at a corner.

Either a simple running stitch or an overhand stitch will work for this job. Whichever is used, be mindful that the tape is securely sewn to the backing close to the yarn whipping. Sew in a neat, straight line, not a wavy one showing lots of backing.

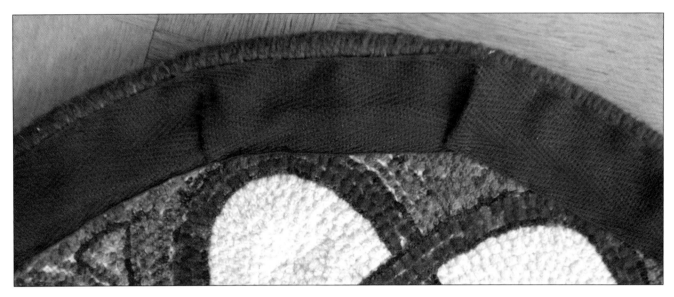

When applying twill tape on the back of a circle, ease it around by placing little tucks along the inside edge of the tape.

The inside edge is never sewn through the loops of a mat; always sew it to the backing. The backside of the loops present themselves as the easiest target to slide the needle through, but this also makes it easier to pull the loops out. I pierce the needle through to the front and gently separate the loops so the thread can run over two or three threads from the backing; then I take the needle through to the back of the mat. Keep your stitches fairly short in length; long stitches create weak points, and the tape will not hold.

Separate the loops to prevent the thread from pulling out any loops.

Miter the twill tape at the corners in the same way the backing was mitred. When the tape has been sewn all around, fold the raw edge of the tape under and overlap the beginning section.

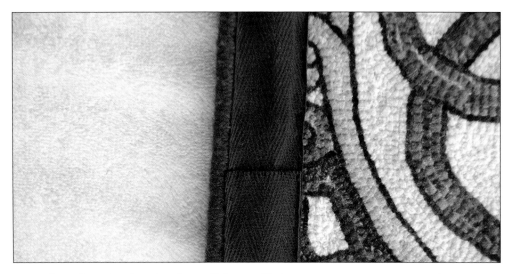

Overlap the beginning of the twill tape to cover any raw edges.

DISPLAYING YOUR CELTIC MAT

Do you want to hang your mat? After the many hours of planning, hooking, and sewing, as well as the expense, it's easy to see why the wall is preferable. There are a number of ways to hang a mat. One method is to sew a sleeve along the top edge of the mat with a second piece of twill tape or other material. A section of doweling or curtain rod slightly wider than the mat can then be slipped through the sleeve. Use a piece of decorative cording wrapped around each end of the rod to hang the mat.

I generally use carpet strips to hang any work that is not destined for the floor. These are not expensive and can be purchased at any hardware store or carpet shop. You must secure the strips to the wall.

There are a number of different models, from a flat wooden strip with teeth to strips made of metal with a decorative curved top that allows the mat to snuggle underneath.

Carpet strips screwed to the wall work nicely to hang a finished mat. The points on the strip must point up.

Over time, the weight of large hung rugs can sometimes cause the bottom to ripple and not hang flat against the wall. It is possible to buy weights at fabric stores to sew on the back of the mat to help stop this. These are flat metal squares with holes in the centers and come in different weights and sizes. They can be sewn along the bottom or to the corners.

It is also possible to have your mat framed in the same manner as a picture. Individual framing shops will have varying methods of treating fabric art. Some will staple the mat, and others will lace the mat over a special mat board. Whichever method you use, there is no need to whip or sew twill tape, but there must be enough backing left to fold over the mat board. Framing is expensive, but sometimes it is the treatment you need.

I have seen mats that have been glued to wood, but I advise against this. Textile museums do not recommend this either because of the interaction between the glue and fabric: over time, the wool can become brittle and change color.

Do consider where to display your finished heirloom. Never hang any textile in direct sunlight—it will fade, even with the dyes used today. Keep it away from any area where food may come in contact with the wool, such as close to a dining room table where small children may sit. It's also never a good idea to hang a textile in or near a kitchen due to cooking smells that can be absorbed in the wool.

What about cleaning? Any spills should be blotted up, not rubbed. Dirt or mud should be allowed to dry and then brushed off with a soft brush. I do vacuum my mats but never with a beater bar or any aggressive attachment. Screen material, such as that found in a window screen, placed over the mat will protect the loops from too much suction. Hooked rugs can be dry cleaned as well, but only if you know your dry cleaner well enough to know he won't damage your rug by over-cleaning or pressing. Keep in mind that if using recycled material, you have an unknown element that may act differently than pure wool, and colors may bleed onto other colors during cleaning.

Where I live, we wait for dry, granular snow and a cold day so it won't melt—we have plenty! Spread your rug out flat, then gently rub the dry snow over the top of the mat. Then lightly brush the snow off with a broom. If the snow and the temperature are cold enough, the mat will not get wet. Further vacuuming can be done if needed when it is brought back inside. Our grandmothers cleaned their mats in the same manner.

The best mats were kept in the parlor, and as they wore out, they were delegated to the kitchen, then to the back porch, and finally to the barn. Ours, with proper care, will last for many more generations and will indeed become family heirlooms that would make our Celtic ancestors proud!

Trifle

1 large loaf of pound cake, cut in thin slices

1 (12-ounce) jar strawberry or raspberry jam

1 1/2 recipes of microwave custard (page 55)

2-3 cups raspberries or strawberries, fresh or frozen (thawed)

1/2 cup sherry or orange juice

½ pint of whipping cream, beaten

Sliced almonds for garnish

Spread one side of each slice of cake with the jam. Spoon a thin layer of custard over the bottom of a trifle dish with high, straight sides. Place one layer of jam-covered sponge cake on top of the custard, and then cover with a thin layer of berries. Drizzle with sherry or juice. Continue with layers of custard, cake, berries, and sherryuntil the bowl is filled; top with beaten whipped cream. Sprinkle with sliced almonds if desired. Scoop and serve.

The last recipe I want to share with you is my family's favorite, and Christmas just wouldn't be right if we didn't have trifle. I hope your family will enjoy it as well.

⑧ Gallery of Celtic Designs

I am lucky to have many talented students and friends who agreed to allow me to highlight and brag about their rugs, and I love doing it! These rugs are true treasures, as are the women who hooked them. Take quick peek, and one can see that although the Celtic color palette is a small one, the variations are endless. No two rugs will ever be the same because each represents the unique personality of the individual hooker. Study these rugs and use them as guides; any hooker from beginner to more advanced will learn from them. Gathered together in this book, they are at your fingertips any time you need inspiration. However, don't just copy what you admire; rather view these mats as teaching tools. Look at how the colors sing together in harmony from rug to rug. Look at how the houses were finished and the rooms decorated. Look at how they differ. Examine the circles, the points, the feathers, and the beauty lines. Make a list of what you like from rug to rug, and when it's time to start your own, you will have a perfect guide to follow—a guide that will help you hook your own Celtic heirloom.

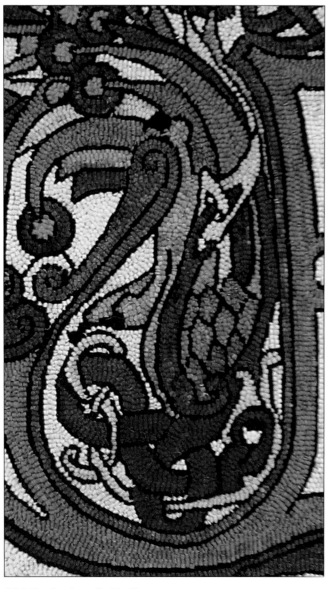
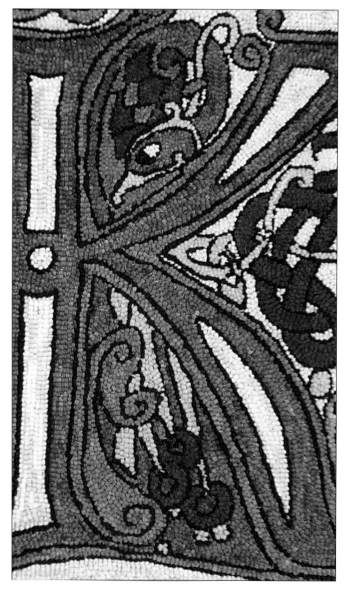

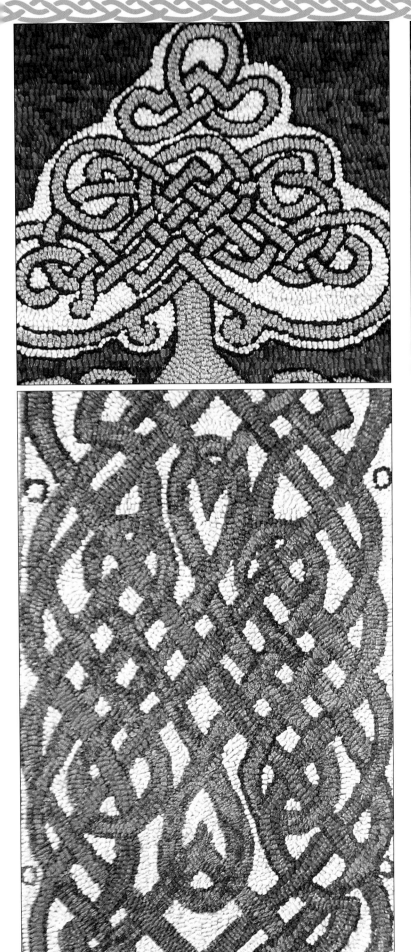
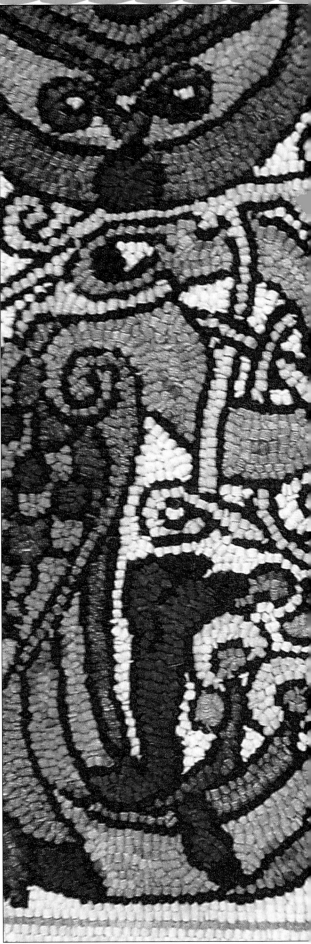

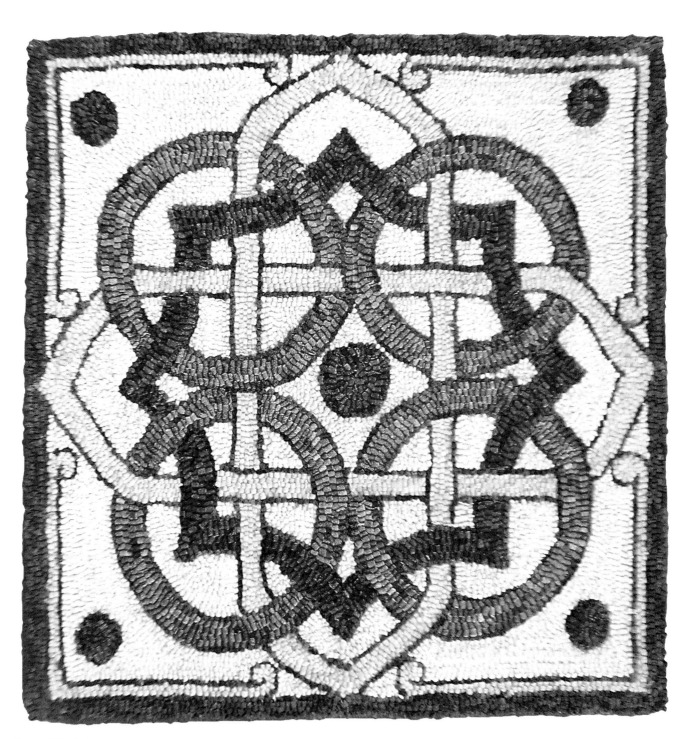

Knot Matrix, *15" x 15", #3-cut wool on rug warp. Designed by David Rankine and hooked by Gail Lambert, Lake Charlotte, Nova Scotia, 2007.*

I love this piece. It's simple and clear and was quick to hook. I hooked the inside brown line first. Then I hooked an equal number of colored strips, followed by the outside brown line. The whole design has an appeal of uniformity.

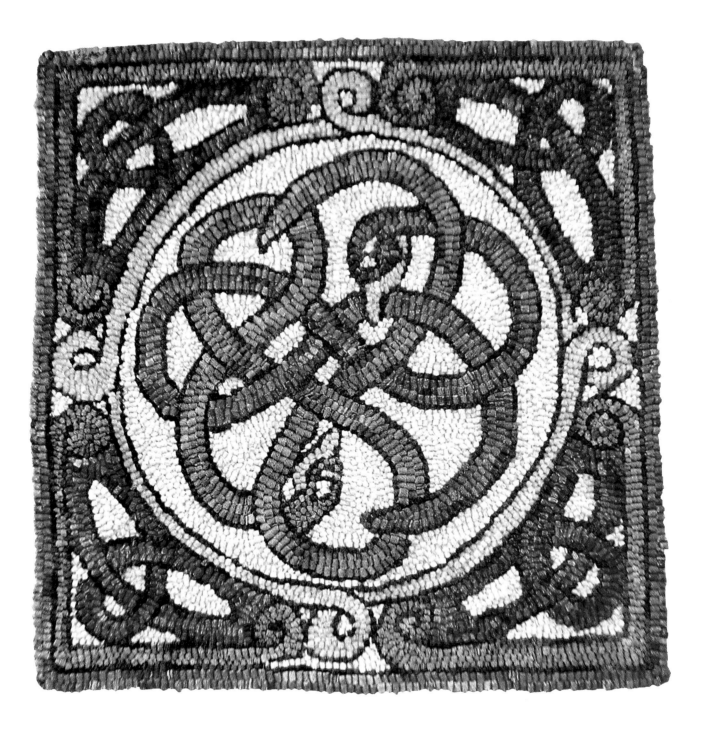

Together, *13″ x 13″, #3- and 4-cut wool on rug warp. Designed by David Rankine and hooked by Gail Lambert, Lake Charlotte, Nova Scotia, 2016.*

In this pattern, the green snake is larger, so I hooked the smaller snake in a brighter color to compensate for its smaller size. If the larger one had been hooked in the brighter blue, the design would have been out of balance.

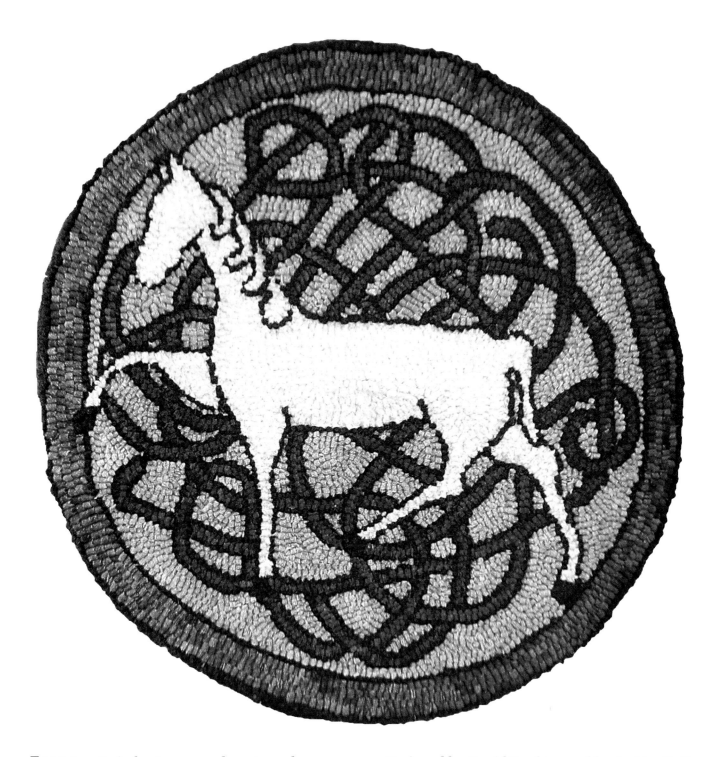

Epona, *14" circle, #3-, 4-, and 5-cut wool on rug warp. Designed by David Rankine and hooked by Gail Lambert, Lake Charlotte, Nova Scotia, 2016.*

Epona, the horse god, was a challenge! Although I hook the outlines in all Celtic pieces right on the lines, it didn't work on this one; the legs and hooves were huge and out of proportion. I hooked this three or four times, trying to get a proper balance. Only by hooking inside the lines was I able to achieve the shape I wanted. The horse was hooked using an interesting sparkle fabric from Dorr Mill. I used the silver version, and the piece comes to life when the light hits the metallic-like threads. However, this fabric can't be used for small cuts.

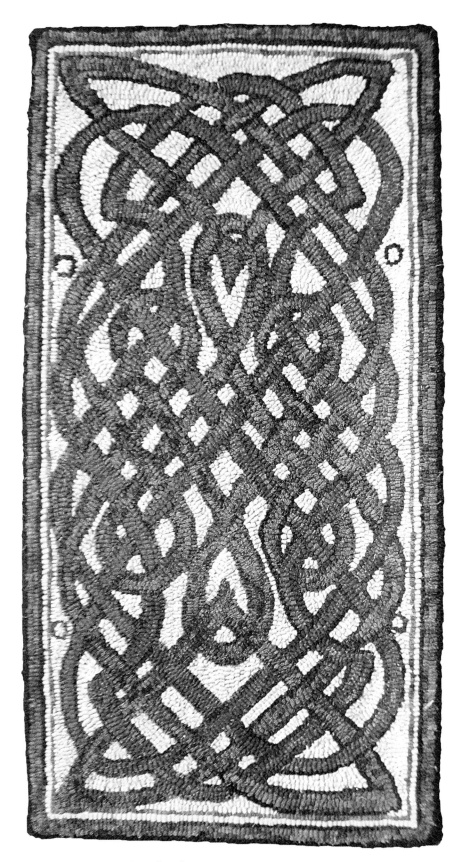

Heart Knot, *12" x 24", #3-cut wool on burlap. Designed by David Rankine and hooked by Gail Lambert, Lake Charlotte, Nova Scotia, 2007.*

This was the first Celtic design I ever hooked. While it is not bursting with color, it does have an intriguing design.

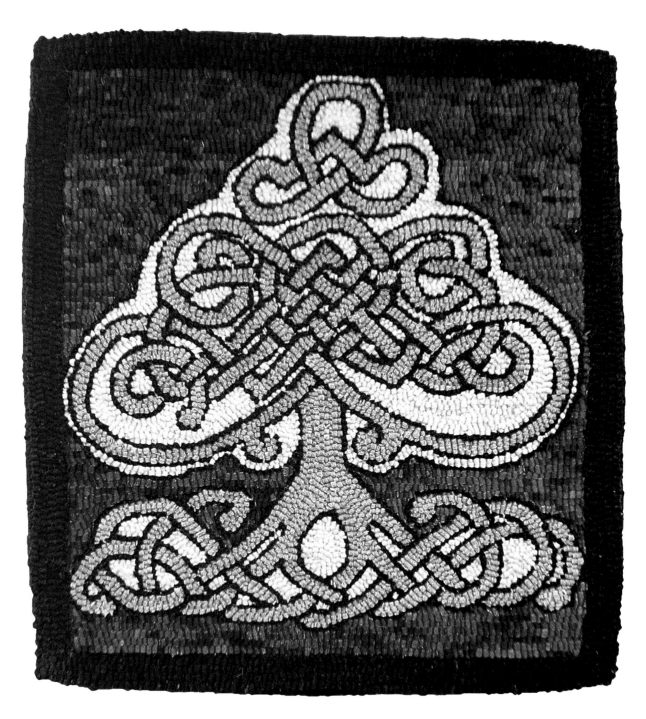

David's Celtic Tree of Life, *14" x 15", #3- and 4-cut wool on rug warp. Designed by David Rankine and hooked by Gail Lambert, Lake Charlotte, Nova Scotia, 2016.*

David's Celtic Tree of Life *design is one of my favorites, and I will be hooking this again! I can imagine hooking four trees, one for each season, with this one representing winter. There are only three colors in this mat, but because of the ribbon pattern, it looks busy. Each small background color had to be hooked beside the ribbon section as the tree progressed. Sometimes I had four black outline strips "parked" while hooking the colored ribbon. Good balance is achieved by hooking with an equal number of strips. I found using three narrow strips was more pleasing than using one wide one.*

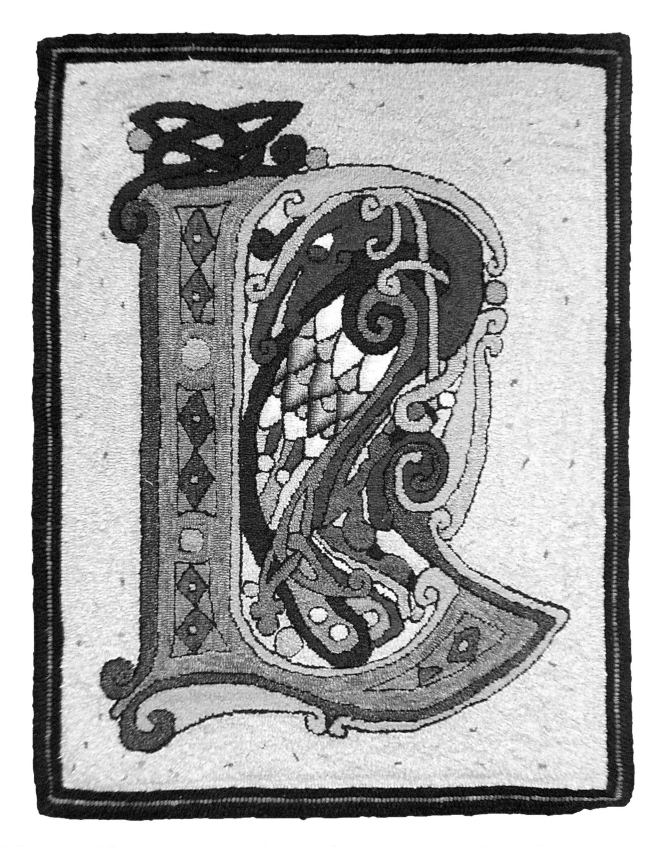

Celtic Letter "L", *21" x 26", #3-, 4-, and 5-cut wool on rug warp. Designed by David Rankine and hooked by Eileen Lopes, Lake Charlotte, Nova Scotia, 2015.*

The dark bird in this mat could have been overpowering; however, the beautiful feathers hooked using graduated color swatches bring a joyful energy to the design and balances nicely with the darker bird. The rug hooker felt the background was too boring, so she randomly hooked little spots of more intense color to brighten the dull tones.

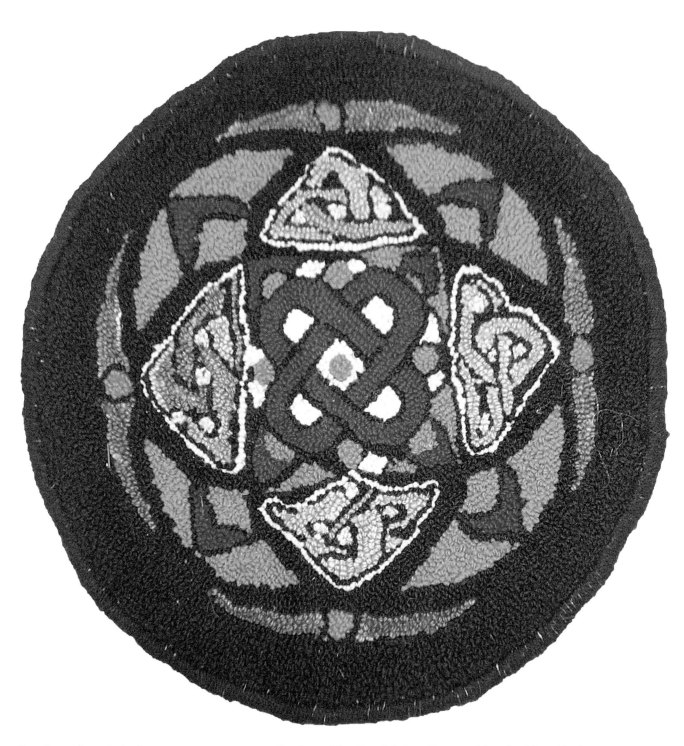

Centered, *17″ circle, yarn on rug warp. Designed by David Rankine and hooked by Gladys McNutt, Truro, Nova Scotia, 2015.*

I like the strong red knot in the middle of this design. Hooking the background in black required a strong central color, and that red knot was perfect.

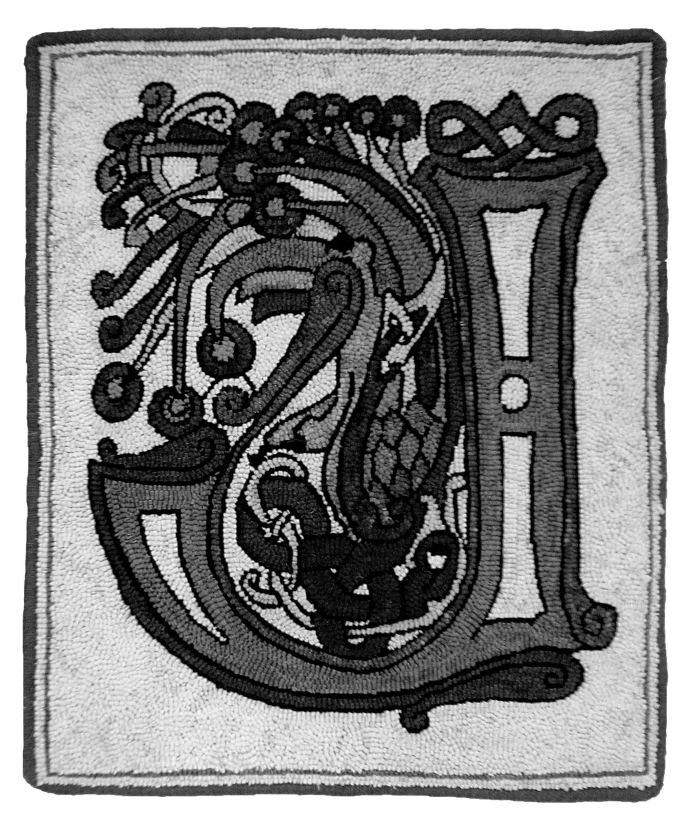

Celtic Letter "J", *21" x 26", #3-, 4-, and 5-cut wool on rug warp. Designed by David Rankine and hooked by Kathy Harrington, Truro, Nova Scotia, 2015.*

The red carried from the bird's head through to its tail works well and provides balance with the red used on the bottom of the letter.

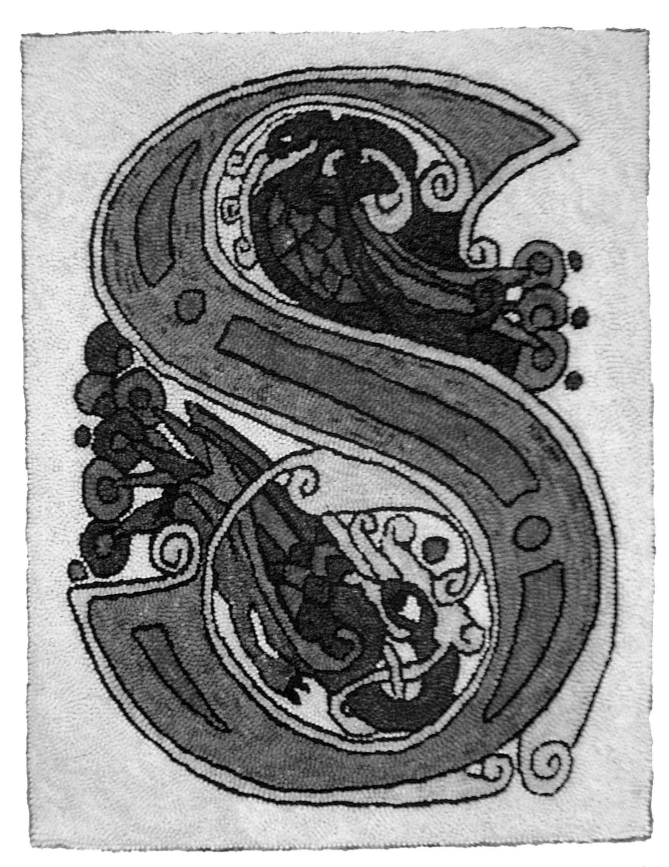

Celtic Letter "S", *21" x 26", #3-, 4-, and 5-cut wool on rug warp. Designed by David Rankine and hooked by Phyllis Stewart-Blois, Truro, Nova Scotia, 2015.*

Using the brighter orange in three sections—the two birds and the main letter—pairs nicely with the darker colors used.

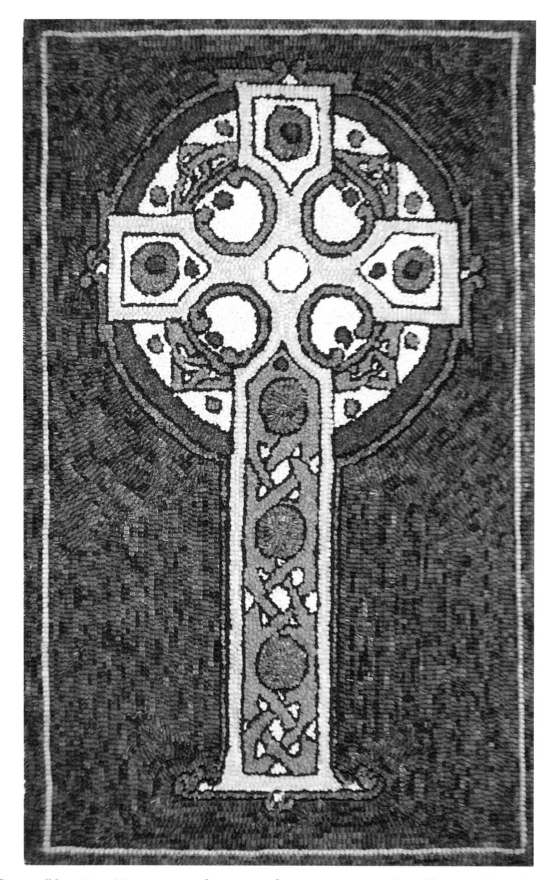

Celtic Cross #1, *17" x 28", #3-, 4-, and 5-cut wool on rug warp. Designed by David Rankine and hooked by Gail MacKinnon, Truro, Nova Scotia, 2015.*

The bright colors used in this design make me think of spring and sunny days. The yellow beauty line around the outside edge complements the main motif of the yellow cross, pulling the whole mat together.

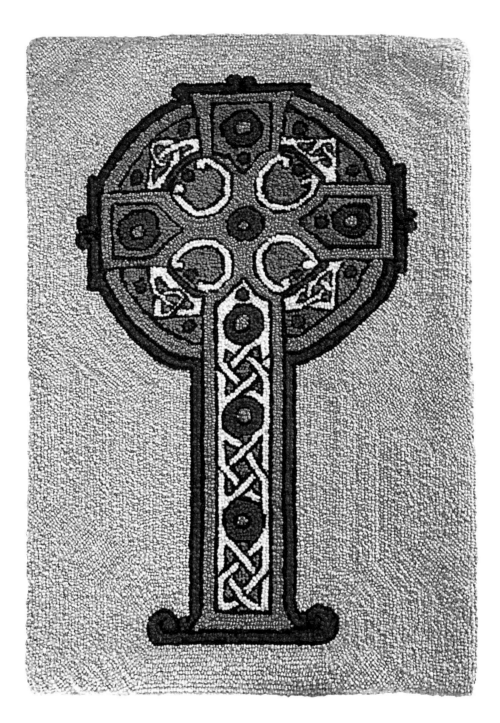

Celtic Cross #1, *17" x 28", yarn on rug warp. Designed by David Rankine and hooked by Maggie Linstead, Truro, Nova Scotia, 2015.*

The beautiful balance of colors in this mat helped to make it a prize winner for one of my students.

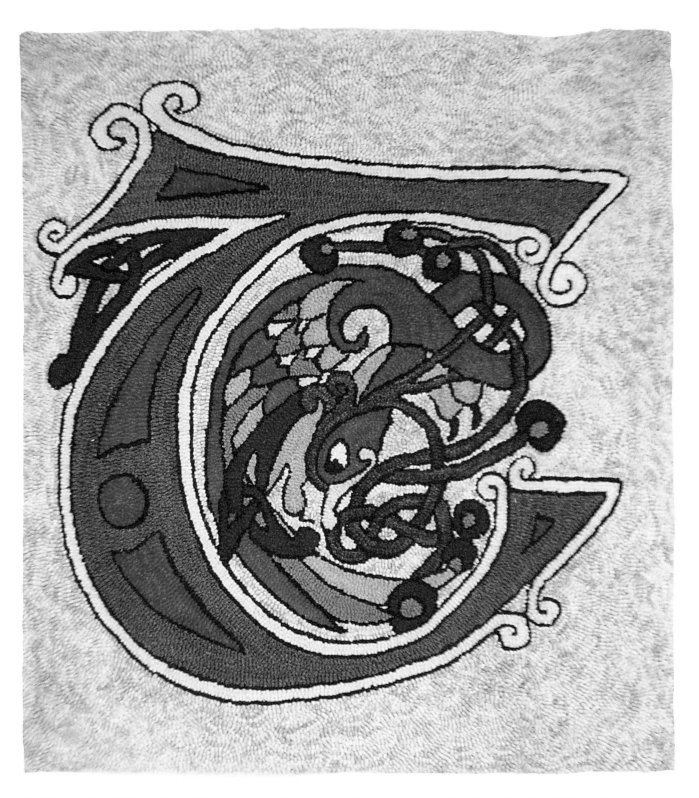

Celtic Letter "T", *21″ x 26″, #3-, 4-, and 5-cut wool on rug warp. Designed by David Rankine and hooked by Beverly Levine, Truro, Nova Scotia, 2015.*

The colors used in this rug mirror those in a Scottish tartan. The lighter spot-dyed background really makes the T stand out.

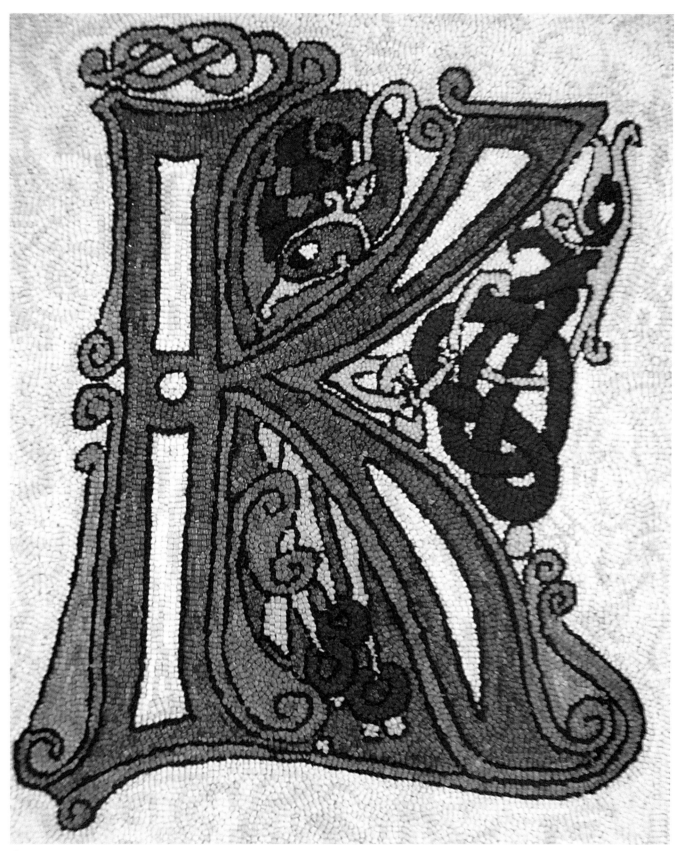

Celtic Letter "K", *21″ x 26″, #3-, 4-, and 5-cut wool on rug warp. Designed by David Rankine and hooked by Kathy Harrington, Truro, Nova Scotia, 2015.*

The background peeking through the main body of the letter provides extra interest in this mat. The lighter shade of blue works well to accentuate the darker blue in the main letter.

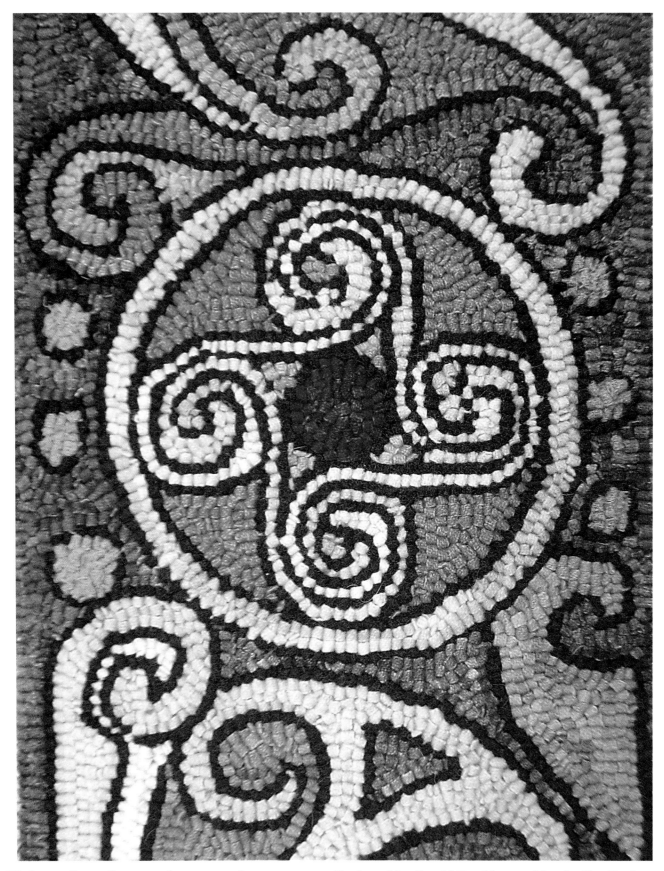

Water, *14" x 34", #3- and 4-cut wool on rug warp. Designed by David Rankine and hooked by Kathy Harrington, Truro, Nova Scotia, 2015.*

Kathy has done a wonderful job on this design. Notice the beautifully hooked black outline!

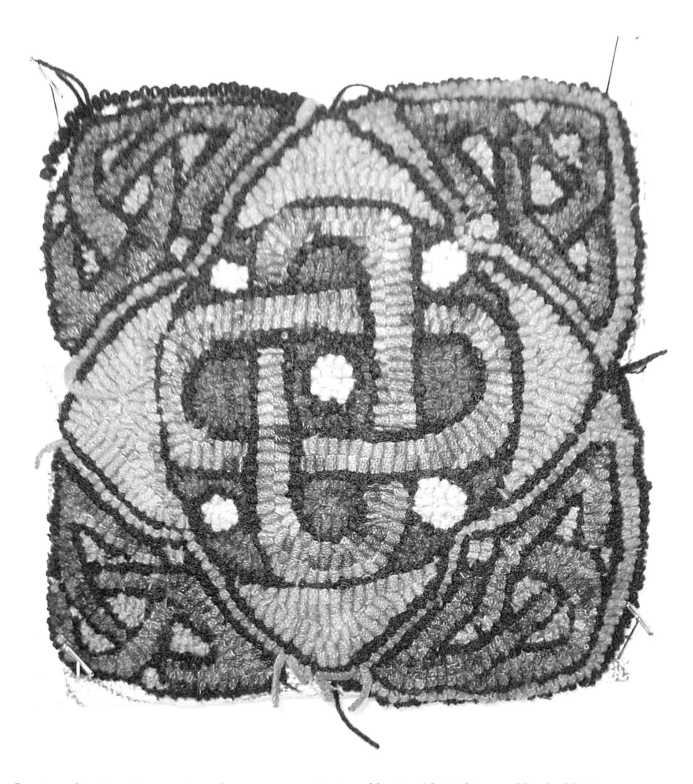

Centered, *17″ x 17″, #3-cut wool on rug warp. Designed by David Rankine and hooked by Dawn Coveyduck, Truro, Nova Scotia, 2015.*

Hooking the background color as the sections are done will help you define the rooms and help you avoid getting lost in the outlining. Note how the tiny sections hooked with only one or two loops help to define the knots. Tiny spaces are important in a Celtic design.

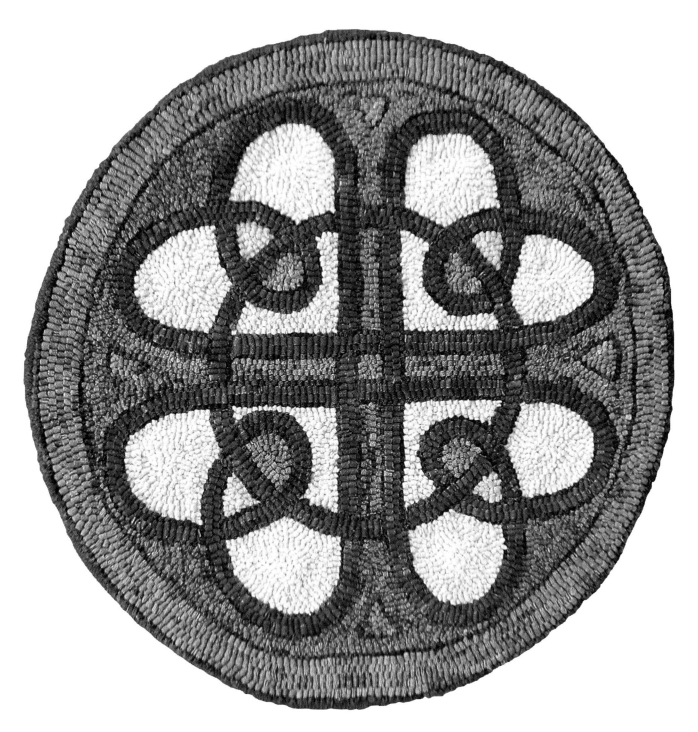

Four Hearts, *17″ circle, #3-, 4-, and 5-cut wool on rug warp. Designed by David Rankine and hooked by Gail Lambert, Lake Charlotte, Nova Scotia, 2015.*

This is a fun design to play with, and it can be hooked in many different ways. Just by changing the inside circle to a different color, you have a very different piece.

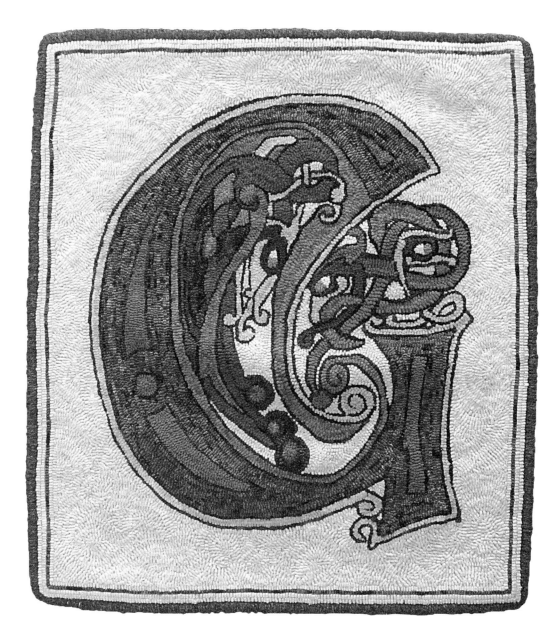

Celtic Letter "G", *21" x 26", #3-, 4-, and 5-cut wool on rug warp. Designed by David Rankine and hooked by Cathy Ooman, Kentiville, Nova Scotia, 2014.*

I like the use of red for the three creatures in this mat. They are strong, and easy to spot, and provide balance and movement.

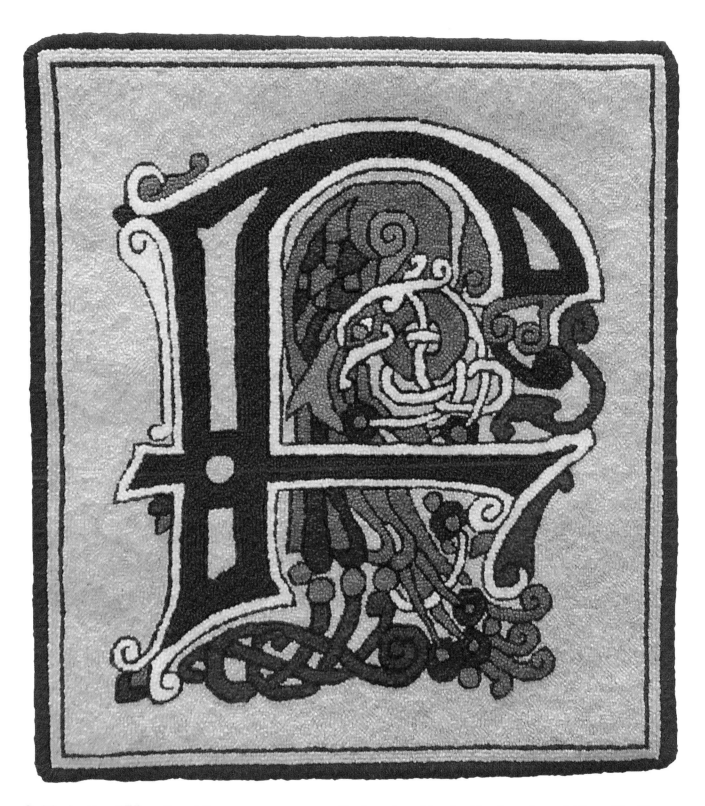

Celtic Letter "F", *21″ x 26″, yarn on rug warp. Designed and hooked by Jane Lessel, Kentville, Nova Scotia, 2014.*

The bright blue on the left side of the letter provides balance and brings the eye back to the main design.

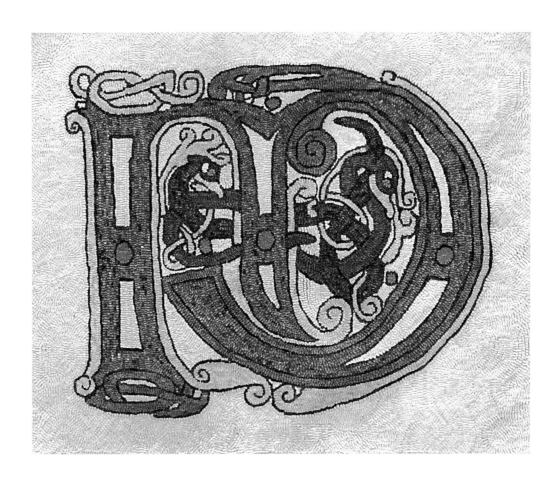

Celtic Letter "M", *21" x 26", #3- and 4-cut wool on rug warp. Designed by David Rankine and hooked by Jean MacDonald, Kentville, Nova Scotia, 2014.*

This letter is well balanced and shows well-executed outlining. Allowing the background color to show through is an effective technique because of the colors of the creatures.

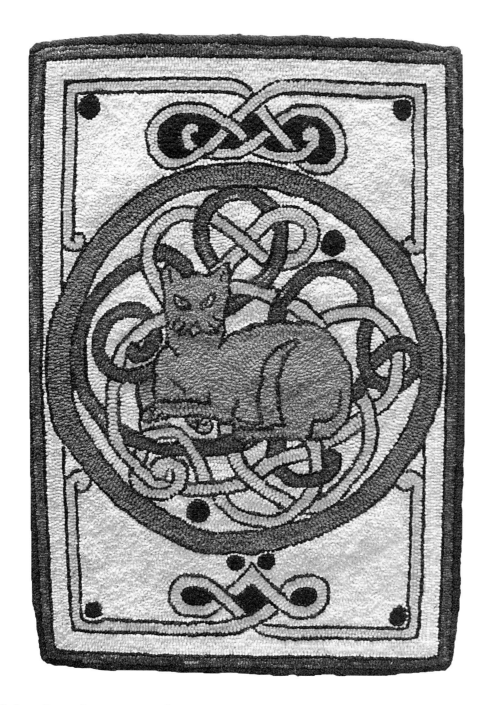

Ever Watchful, *15″ x 22″, #3-cut wool on rug warp. Designed by David Rankine and hooked by Joan Albert, Port Williams, Nova Scotia, 2014.*

The blue cat really stands out in this design, and the dark blue in the knot and circles adds dimension to the mat.

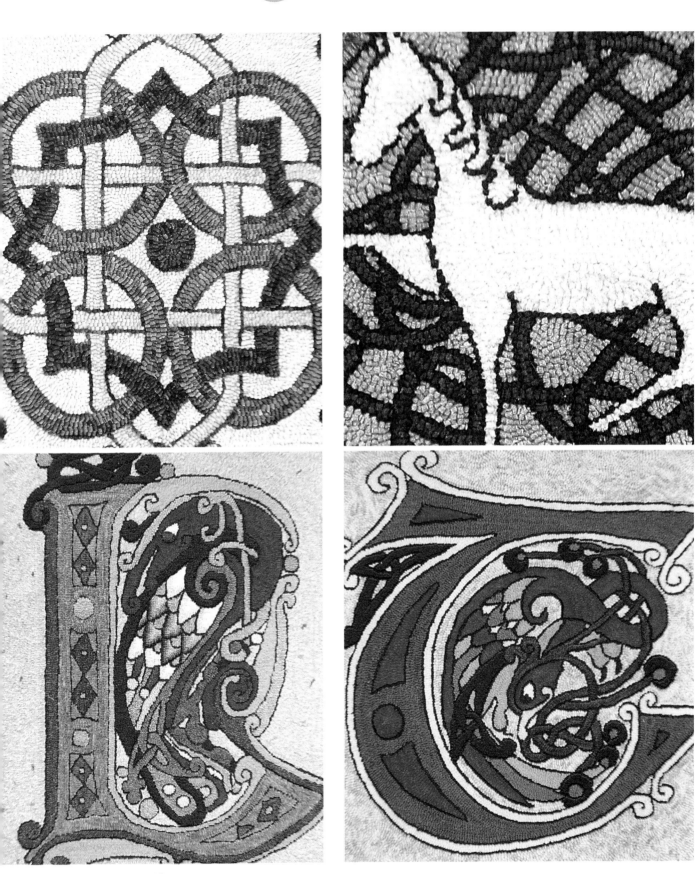

INSTRUCTIONS

When I saw these new patterns, shown here for the first time, I was so excited—David has created twelve masterpieces! He designed patterns for all levels of expertise and all interests. They are presented here in order of difficulty, so please don't start with David's *Knot Deluxe*.

If you are a beginner, start with one of the simpler designs so you don't become discouraged. Work at your own pace. Take your time—it's not a race. Study your pattern carefully before you start. Study the beautiful photos for ideas. You may find as you progress that you have a preference for one particular style, perhaps knots and not letters, and that's great. The variety of Celtic patterns is intriguing. In no time at all you will be hooking Celtic masterpieces that will become wool works of art!

Permissions

You are granted permission to use these patterns for personal use only, not for mass production or resale. You can enlarge them by going to any office supply store or copy shop; the experts in the copy shops can enlarge them from a small pillow size to a large floor mat size. I suggest that you make more than one copy so that you can play with your color plan.

Permission to copy shop

You may make up to 10 copies of a pattern for a person requesting copies/enlargements.

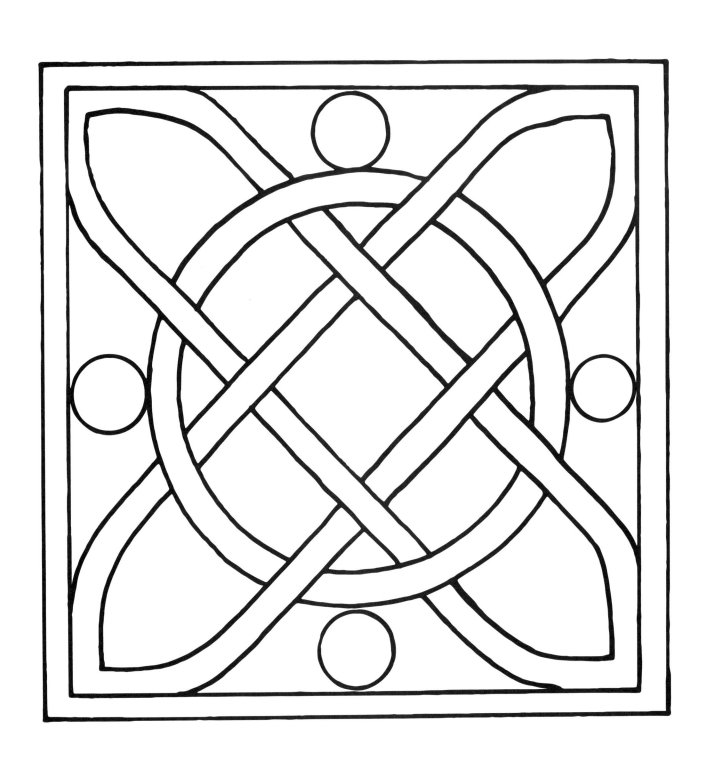

Simple Knot

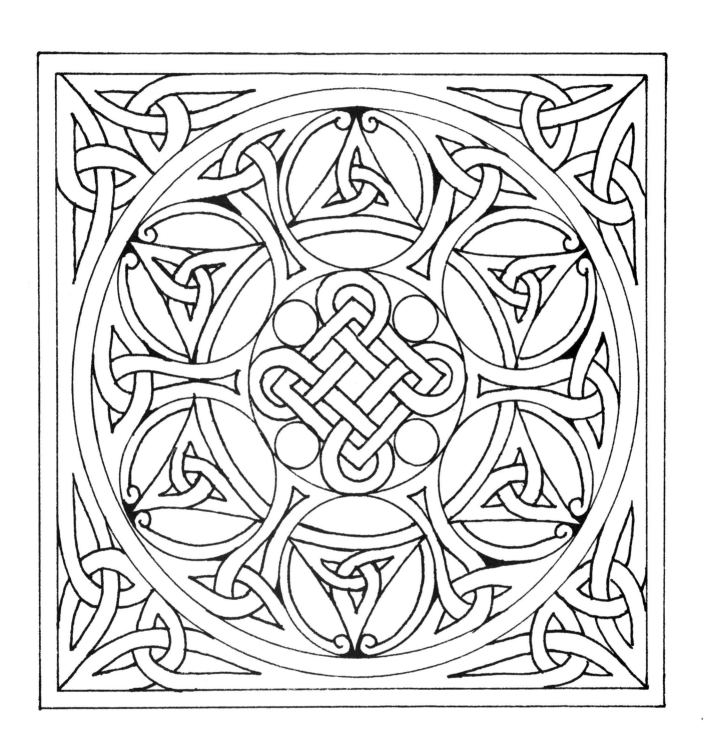

Core of Knots

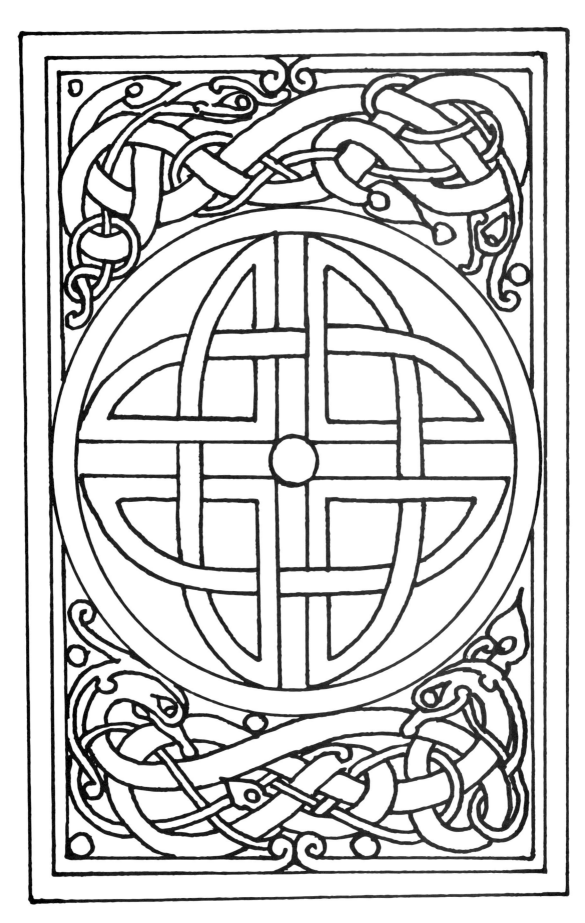

Serpents and Knots

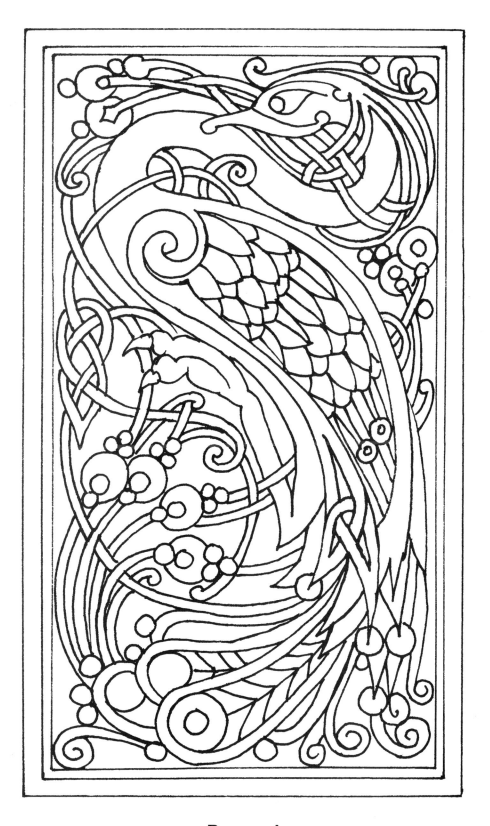

Peacock

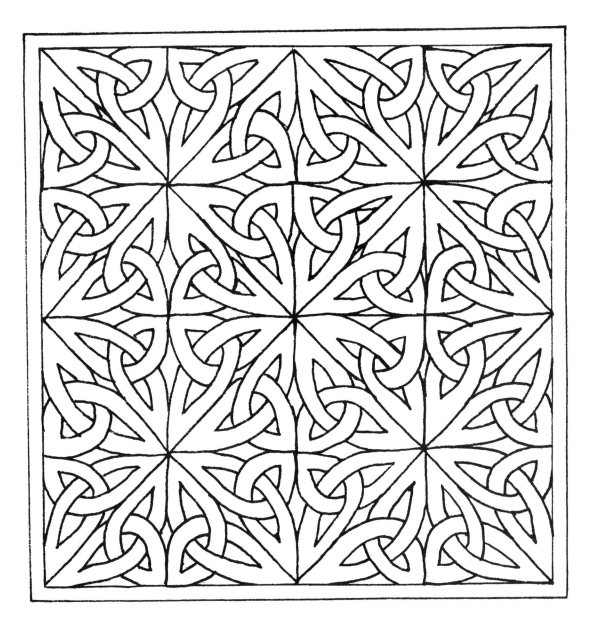

Field of Knots

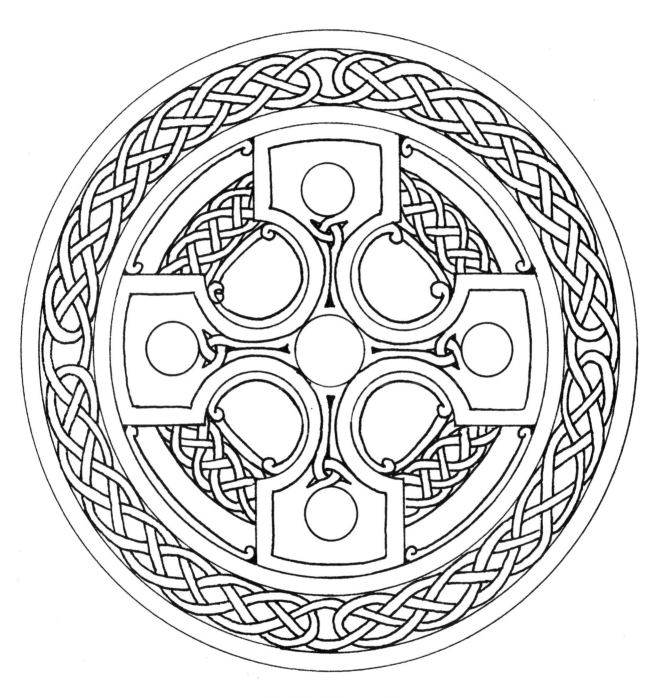

Celtic Cross 1

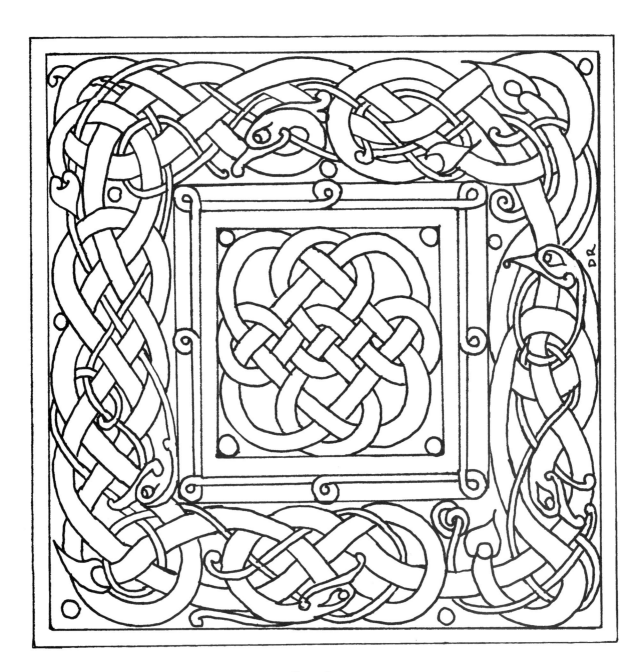

Snakes

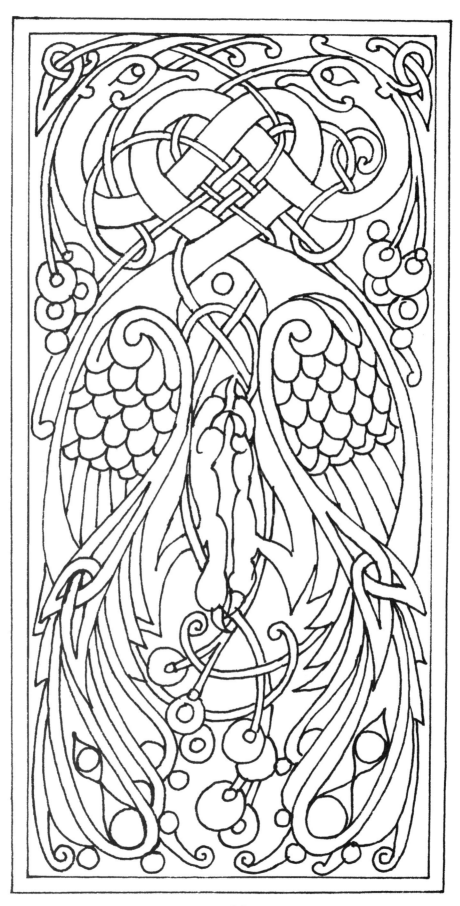

Love Knot

Celtic Cross 2

Spirals

Illuminated R

Knot Deluxe

The letter "E"

I will have achieved three-quarters of my current Celtic journey when I finish this letter E. I set out to hook one Illuminated Letter for each of my four children—this is the third, with one more to go. It has been a labor of love and exploration, and after the last child's initial is hooked, I will hook a "G" just for me! Then it will be on to a Celtic centerpiece for my table . . . then there is that long narrow space between two windows calling out for something . . . and what about a . . .

⑩ Conclusion

This book is a labor of love and I hope you find inspiration and enjoyment in these pages. I have been drawn to the Celtic world and Celtic designs for many years and never grow tired of learning new facts discovered about these fascinating ancient people and their art. David Rankine has proven to be my best personal find—he has a wealth of information that he is happy to share. He has a kind soul that inspires me daily.

We have organized this book in a manner that would lead you gently from pulling your first loop in a Celtic design all the way to comfort and confidence as you hook a complicated pattern. The photos of the completed rugs will guide and inspire you, and entice you into this marvelous world.

We hope you have enjoyed the process. We certainly have!

References

Backhouse, Janet. *The Lindisfarne Gospels*. Phaidon Press Limited, 1981.

Cunliffe, Barry. *The Ancient Celts*. Oxford University Press, 1997.

De Hamel, Christopher. *A History of Illuminated Manuscripts*. Phaidon Press Limited, 1986.

Lincoln, Maryanne. *Comprehensive Dyeing Guide*. Stackpole Books, 2005.

Mackworth-Praed, Ben. *The Book of Kells*, Studio Edition. Gardners Books, 1993.

MacLean, J. P. *Outposts of Celtica: History and Heroes in the Celtic World*. Glen Margaret Publishing, 2009.

Matthews, Caitlin. *The Elements of the Celtic Tradition*. Element Books Limited, 1991.

Meehan, Bernard. *The Book of Kells*. Thames & Hudson, 1994.

Shepherd, Gene. *The Rug Hooker's Bible*. Rug Hooking Magazine, 2005.

Tanner, Marcus. *The Last of the Ancient Celts*. Yale University Press, 2004.

Your Free Trial Of

R·U·G HOOKING

MAGAZINE

Join the premium community for rug hookers! Claim your FREE, no-risk issue of *Rug Hooking* Magazine.

Sign up to receive your free trial issue (a $9.95 value).

Love the magazine? Simply pay the invoice for one full year (4 more issues for a total of 5).

Don't love the magazine? No problem! Keep the free issue as our special gift to you, and you owe absolutely nothing!

Claim Your FREE Trial Issue Today!

Call us toll-free to subscribe at (877) 297 - 0965
Canadian customers call (866) 375 - 8626
Use PROMO Code: **RHCR917**

- -

Discover inspiration, techniques & patterns in every issue!

Yes! Rush my FREE issue of *Rug Hooking* Magazine and enter my subscription. If I love it, I'll simply pay the invoice for $34.95* for a one year subscription (4 more issues for a total of 5). If I'm not satisfied, I'll return the invoice marked "cancel" and owe absolutely nothing.

SEND NO MONEY NOW-WE'LL BILL YOU LATER

Cut out (or copy) this special coupon and mail to:
Rug Hooking Magazine Subscription Department
PO Box 2263, Williamsport, PA 17703-2263

First Name Last Name

Postal Address City State/Province Zip/Postal Code

Email Address

* Canadian subscribers add $5/year for S&H + taxes.
Please allow 6-8 weeks for delivery of the first issue. RHCR917

105

Our Annual Celebration of Gorgeous Hand-Hooked Rugs

The 27th annual edition of *Rug Hooking* Magazine's yearly juried competition showcases the best of the best. Each winning rug is presented as a two-page spread that includes a photo of the entire rug, a close-up of compelling details, and illuminating insights from the artist and the judges. *Celebration 27* is a rich source of inspiration for all who are interested in fiber arts.

Whether you design and hook rugs yourself or draw inspiration from the work of others, you will enjoy the latest addition to our celebratory collection. With 72 traditional and original rugs to enjoy, plus 58 close-up details, *Celebration 27* is the essential guide to the year's best rugs from around the world.

Copies are in limited supply, so don't miss your opportunity to relish the most breathtaking rugs of the year!

Call us toll-free to order at (877) 297 – 0965

Canadian customers call (866) – 375 - 8626

Get Your Copy of *Celebration 27* Today!

C27C9

106